# PRAISE for SANDOR ELLIX KATZ

"One of the unlikely rock stars of the American food scene."
— *NEW YORK TIMES*

"[Katz's] books have become manifestos and how-to manuals for a generation of underground food activists."
— *THE NEW YORKER*

"Sandor Katz is the OG." —RENÉ REDZEPI, chef, co-author of *The Noma Guide to Fermentation*

"[A] fermentation master."
— *WALL STREET JOURNAL*

"Sandor is the Johnny Appleseed of fermentation."
—MICHAEL POLLAN

"None of us would be so aware of the vastness of [fermentation] were it not for the work of a true king who'd done it all long before I was but a thought in gastronomy: Mister Sandor Katz."
—DAVID ZILBER, chef, co-author of *The Noma Guide to Fermentation*

FERMENTATION as METAPHOR

## Also by Sandor Ellix Katz

*Wild Fermentation:*
*The Flavor, Nutrition, and Craft*
*of Live-Culture Foods*

*The Art of Fermentation:*
*An In-Depth Exploration of Essential Concepts*
*and Processes from Around the World*

*The Revolution Will Not Be Microwaved:*
*Inside America's Underground Food Movements*

# FERMENTATION

## as METAPHOR

## SANDOR ELLIX KATZ

Chelsea Green Publishing
White River Junction, VT
London, UK

Project Manager: Patricia Stone
Project Editor: Benjamin Watson
Copy Editor: Laura Jorstad
Proofreader: Angela Boyle
Designer: Melissa Jacobson

Printed in the United States of America.
First printing September 2020.
10 9 8 7 6 5 4 3 2 1        20 21 22 23 24

**Our Commitment to Green Publishing**
Chelsea Green sees publishing as a tool for cultural change and ecological stewardship. We strive to align our book manufacturing practices with our editorial mission and to reduce the impact of our business enterprise in the environment. We print our books and catalogs on chlorine-free recycled paper, using vegetable-based inks whenever possible. This book may cost slightly more because it was printed on paper from responsibly managed forests, and we hope you'll agree that it's worth it. *Fermentation as Metaphor* was printed on paper supplied by Versa Press that is certified by the Forest Stewardship Council.

**Library of Congress Cataloging-in-Publication Data**
Names: Katz, Sandor Ellix, 1962– author.
Title: Fermentation as metaphor / Sandor Ellix Katz.
Description: White River Junction, VT : Chelsea Green Publishing, 2020. | Includes bibliographical references.
Identifiers: LCCN 2020029366 (print) | LCCN 2020029367 (ebook) | ISBN 9781645020219 (hardcover)
 | ISBN 9781645020226 (ebook) | ISBN 9781645020233 (audio)
Subjects: LCSH: Fermentation. | Fermented foods.
Classification: LCC TP371.44 .K3696 2020 (print) | LCC TP371.44 (ebook) | DDC 664/.024—dc23
LC record available at https://lccn.loc.gov/2020029366
LC ebook record available at https://lccn.loc.gov/2020029367

Chelsea Green Publishing
85 North Main Street, Suite 120
White River Junction, Vermont USA

Somerset House
London, UK

www.chelseagreen.com

MIX
Paper from
responsible sources
FSC® C005010
FSC
www.fsc.org

*Dedicated to bubbly excitement,*
*in its infinite effervescent manifestations*

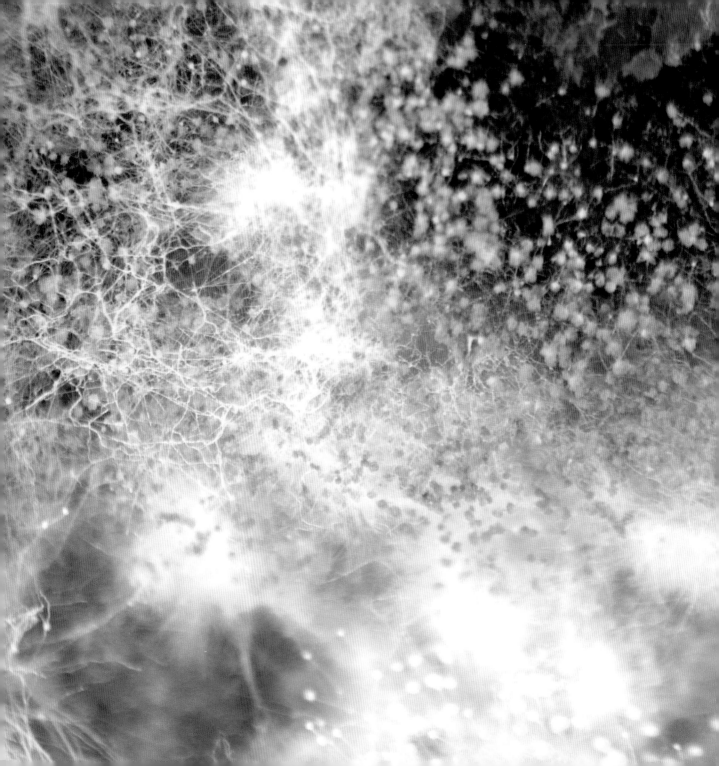

# the complexity of membranes and the beauty of the unseen

It can be appealing to think of certain things in stark, absolute categories. There's good and bad, hot and cold, clean and dirty; there's kindness and cruelty; there's Heaven and Hell. In political reporting we hear about red states and blue states, though everywhere there is a diversity of opinion, even where the vast majority feels one way or another. In most contexts gender is seen as male or female, despite the fact that most of us embody some blend of masculine and feminine aspects, and despite the presence everywhere of people who do not neatly conform to one or the other. In reality most things are not black or white; they exist as in-between shades of gray, or really all over the color spectrum.

If categories can never be absolute, then neither are edges, boundaries, or membranes. Consider our skin: It is an edge that separates that which is within us from that which is outside us. Yet sunlight absorbs into it; sweat and sometimes blood and pus come out of it; mosquitoes and countless other creatures can pierce it; infections, toxins, and other conditions can cause it to rot; heat and cold and many chemicals can burn it; and bacteria, fungi, viruses, and other microorganisms inhabit every bit of it, existing in elaborate, dense

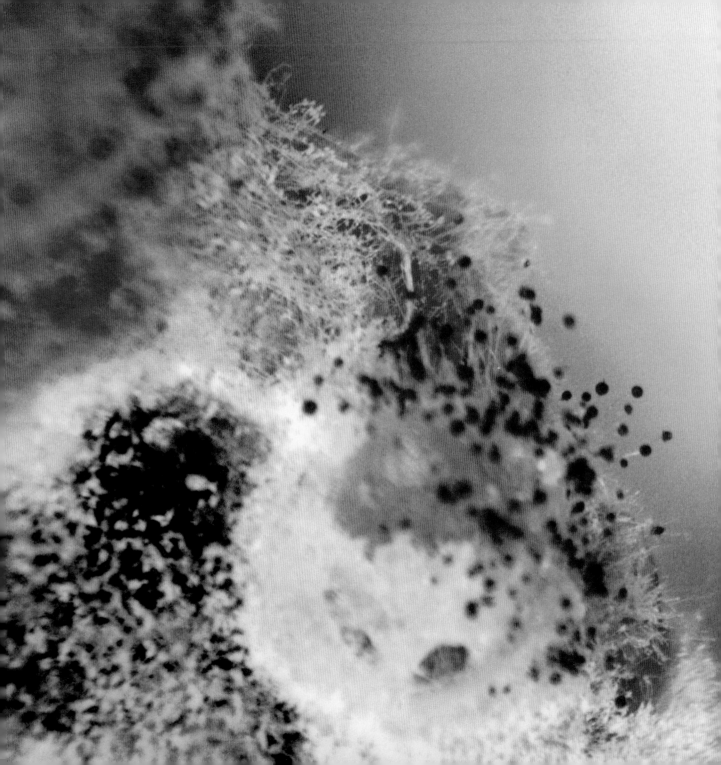

communities that vary with the environmental conditions of different parts of our bodies. The skin on each of us, which we think of as the boundary between ourselves and the world beyond, is home to many more microbes than there are humans on the Earth, and these microscopic beings, in symbiotic relationships with us as well as one another, spin elaborate biofilms, constantly exchange metabolic by-products as well as genes, and mediate much of our interaction with the world around us. Even beyond our skin, each of us is host to a microbial force field, a unique microbial signature that emanates with our body heat.[1]

Our skin, like the membranes of every living organism and cell (in fact, like all borders, membranes, and edges), is complex. From a distance, or in the abstract, these edges may appear to be sharp, hard dividing lines. But up close they are textured, supporting a multitude of smaller structures, biodiverse and selectively permeable.

All along, throughout our long evolutionary history, this complexity and biodiversity has been with us, though the extent of it has been and remains something of a mystery. Many people in our time, even with the benefit of current scientific understanding, continue to regard microorganisms in general as mortal enemies. As I complete this book, in the face of the COVID-19 pandemic, demand for chemical sanitizing products is greater than ever, as people desperately seek to avoid contact with the novel coronavirus in order to

slow its spread. This is vitally important, and I am trying like most everyone to isolate, distance, wash my hands frequently, and strategically reduce my risk of exposure. But realistically, all we can do is slow transmission, because eventually, inevitably, nearly all of us will be exposed.

Our existential context is a microbial matrix. We are continually learning more about how critically important the vast microbial populations everywhere are, not only bacteria but also fungi, viruses, and all the others. Forms of life are not bad or good; we exist in all our co-evolved complexity, a vast matrix of intertwining life-forms at different scales, interacting, mutually coexisting, and feeding off one another, in ways we are just beginning to recognize.

Mutual coexistence, however perceived (or not), shapes cultural evolution, and since prehistoric times people have learned to work with invisible life forces, such as bacteria and fungi, in the context of fermented foods and beverages, as well as agricultural methods, fiber arts, animal husbandry, and more. Human cultures around the world have recognized the invisible force of fermentation in mystical ways, as reflected in the gods and goddesses and mythical figures, and the stories and ritual ceremonies found in diverse traditions. There is even speculation that Amerindian healers may have perceived microbes and guided Western science to investigate their role.[2]

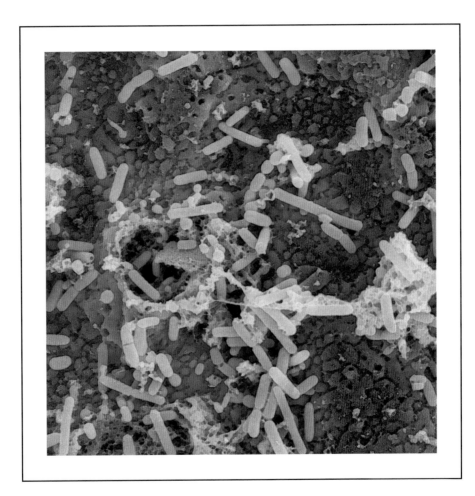

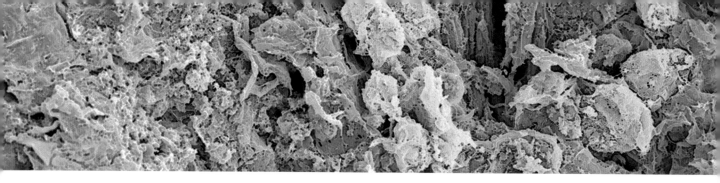

But only with increasingly sophisticated tools have we begun to witness and comprehend the complexity of the ecosystems upon, within, and all around us. From Antonie van Leeuwenhoek's seventeenth-century descriptions of animalcules, via Louis Pasteur's nineteenth-century innovations in microbial identification and isolation, to modern DNA sequencing and a multitude of new microscopy technologies, we have been able to grasp more clearly, as well as see more vividly, the brilliant diversity of life.

. . . . . .

Stemming from my broader obsession with all things fermented, I have developed a passion for photographing fermented foods and beverages in order to see and share their remarkable and awe-inspiring beauty. Sometimes I shoot close-ups of especially vigorous bubbles or interesting surface textures. Sometimes I use a stereoscope, also known as a dissecting microscope, which is not quite as powerful as a slide microscope but has a big advantage in simplicity: Instead of having to prepare a slide, I can just place a sample of food under it and focus on the food at different depths, revealing different elements. With filamentous fungi such as koji and tempeh, as well as with random leftover food that gets moldy, the images

6

captured by the stereoscope can be gorgeous and dramatic. Unfortunately, the stereoscope's relatively limited level of magnification and resolution does not render bacteria visible. I have taken photos through my home microscope of slides prepared from various ferments, and bacteria are clearly visible but at fairly low resolution. I've been extremely fortunate to have been able to access a scanning electron microscope with much greater magnification and incredible resolution, thanks to helpful collaboration with the Fermentation Sciences program and the Interdisciplinary Microanalysis and Imaging Center at Middle Tennessee State University. Because these images do not use light, they do not convey color, so for this book we have taken some liberties in colorizing them.

These images are not meant to illustrate anything in particular, except for the sheer beauty and complexity of microbial structures and communities. Seeing them takes us far from absolute boundaries and rigid categories. They force us to reconceptualize. You could say they make us ferment.

## fermentation as metaphor

I am deeply devoted to my practice of fermentation. In my home at this moment, I'm tending two long-term sourdough starters, one

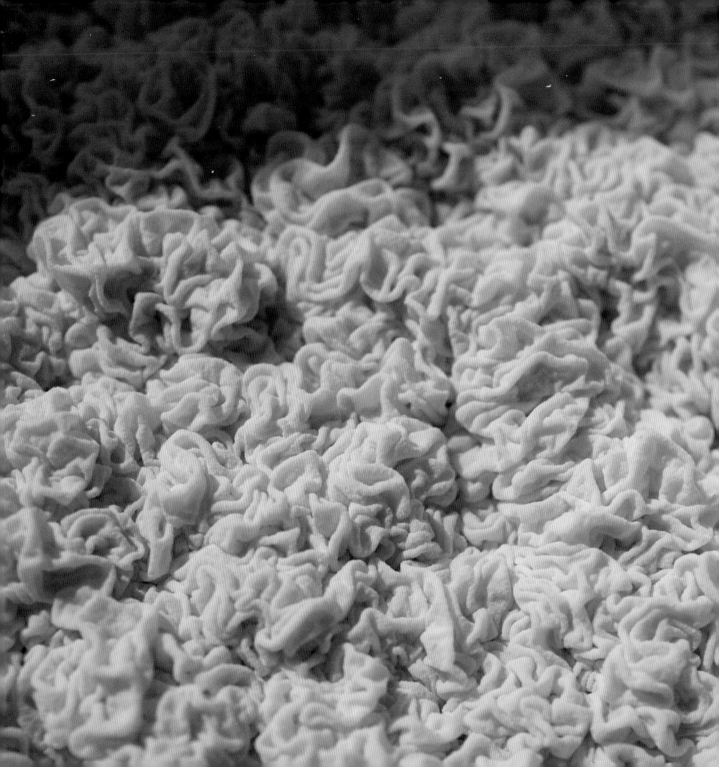

wheat and one rye, along with yogurt, and jun, a cousin of kombucha; periodically I dip into large vessels filled with half a year's supply of kraut and kimchi while I wait for misos and shoyu and doubanjang and mirin and takuan and salo and saké and various country wines and meads to slowly ferment. In this realm there is a lot of waiting.

As my personal obsession with the microbial transformations of foods and beverages developed into books and a career as a fermentation revivalist, I have continued to ferment and learn and experiment in my home kitchen. I have had the great privilege to teach in many different parts of the world, and my travels have enabled me to taste and see incredibly varied fermented foods and beverages from wildly diverse cultural traditions, endlessly fascinating (and delicious). Yet the more I ferment, and the more I think and talk and learn about fermentation, the more I realize that what is even more exciting to me about fermentation than its practical manifestations is its profound metaphorical significance.

The English language uses the word *fermentation* to describe not only the literal phenomenon of cellular metabolism that it is—microorganisms and their enzymes digesting and transforming nutrients—but also much more broadly to indicate a state of agitation, excitement, and bubbliness. The expansive metaphorical possibilities of fermentation arise from the etymological roots of the word, from the Latin *fervere*, which means "to boil." Long before the relatively recent

scientific understanding of fermentation in the late nineteenth century as the work of bacteria and fungi, it was widely recognized by the bubbles that it (generally) creates. Therefore, anything bubbly, anything in a state of excitement or agitation, can be said to be fermenting.

According to the venerable *Oxford English Dictionary*, the earliest documented figurative use of the word *fermentation* in a surviving document comes from a Bible commentary, circa 1660, titled *The Treasury of David*, and is rather lurid: "A young man . . . in the highest fermentation of his youthful lusts." And nearly as early, the term was applied to religious devotion, in this 1672 citation: "The Ecclesiastical Rigours here were in the highest ferment." A 1681 political analysis observed: "Several Factions from this first Ferment, Work up to Foam, and threat the Government."

Fermentation is extremely versatile as a metaphor. Inside our minds, frequently, ideas ferment as we think about them and imagine how they might play out. Feelings too can ferment, as we process them and they move through us. Sometimes this interior ferment transcends our individual experience and grows into a broader social process. In metaphor, as in the biological phenomenon, there is nothing that cannot be fermented. For decades now as a reader, ever since I began taking note of all things fermented, I have noticed in writing many varied metaphorical uses of the word *ferment*. "In the musical ferment of the late '60s, influences were coming from every direction,"

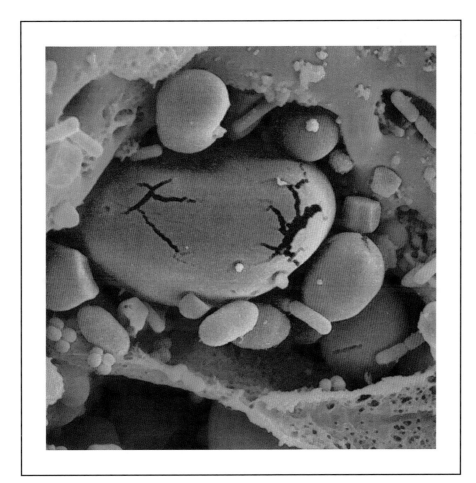

according to one article. "In the 1920s, Punjab was in religious ferment," stated another. An artist's obituary noted that he arrived in New York in 1955 and "was quickly swept up in the artistic ferment of the time." The editor of a political journal was quoted in 2017 as saying, "It took a Trump, of all people, to allow for a certain level of intellectual ferment to take place."

Certainly no particular ideology has a monopoly on fermentation. Intellectual, social, cultural, political, artistic, musical, religious, spiritual, sexual, and other forms of bubbly excitement are part of the range of human experience. In any realm of our lives, it is possible to get caught up in a feeling of shared effervescence. We should all be so lucky. Whatever the context, like its literal twin, metaphorical fermentation is an unstoppable force that people everywhere have harnessed, and gotten caught up in, in all sorts of different ways.

Fermentation can be driven by hopes, dreams, and desires; or by necessity, desperation, and anger; or by other forces altogether. Fermentation is always going on

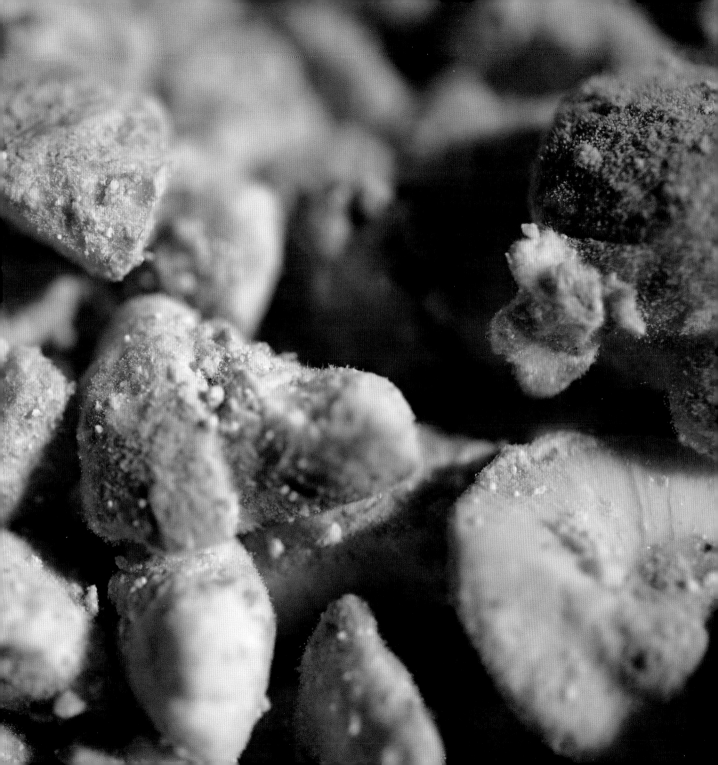

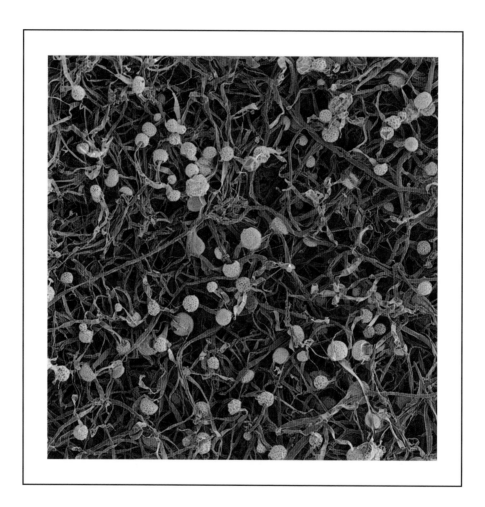

somewhere, though generally not everywhere. Sometimes in its absence it can seem elusive. But when metaphorical fermentation occurs, it often spreads, transforming what was into what's next. Fermentation is no less than an engine of social change.

As a force for change, fermentation is relatively gentle. Bubbles are not flames. Contrast fermentation with that other transformative natural phenomenon: fire. Fire destroys whatever lies in its path. Fermentation is not so dramatic; its transformative mode is gentle and slow. Steady, too. Driven by bacteria that spawned all life on Earth and continue to be the matrix of all life, fermentation is a force that cannot be stopped. It recycles life, renews hope, and goes on and on.

From my perspective, fermentation is generally a good thing, in both its culinary manifestations and its metaphorical ones. But just as some people fear and revile the strong recognizable flavors and aromas of certain fermented foods, or even the idea of them, others think the world would be a better place if everyone understood and accepted their role in it, and didn't ask too many challenging questions; in other words, if bubbliness, agitation, and fermentation were minimized. Also, hateful and corrosive ideas can result from bubbliness and agitation, just as social justice can. The mass protests against racism and police brutality are examples of fermentation, but so is the surge of racism and anti-immigrant xenophobia around the world, and people feeling increasingly

emboldened to give public expression to white supremacist ideas. Fermentation is a force that cannot be controlled, and the changes it renders are not always desirable. Even so, the metaphorical ferment is an unending source of new ideas, dynamic energy, and inspiration, and our best hope for regeneration. "What fermentation shows us is the invisible connections of everything," writes Mercedes Villalba in her *Fervent Manifesto*. "You learn to cultivate the future."[3]

## we need the bubbling transformative power of fermentation

These are very scary and uncertain times. The specter of climate change alone calls everything we have known into question: rising temperatures; melting glaciers; rising seas and shifting currents; more extreme weather patterns, with bigger, more dangerous storms, displacing growing numbers of people; less predictable agriculture with resulting crop failures; new vulnerabilities to pests and diseases; and a cascade of effects as yet unrecognized or unimagined.

Mass extinctions are already occurring, and ecological balances are destabilized. Our insatiable appetite for resources not only

accelerates climate change but also leads to deeper and more destructive extraction practices. Income inequality grows ever starker as technology and cheaper globalized labor replace workers. Racism and sexism persist, both in systemic structures, and spread and exploited by a growing politics of resentment.

The shocking jolt of the COVID-19 pandemic on all social, public, and economic life illustrates just how vulnerable our entire mass society is to disruption. In this case it was a virus that sent shock waves that have been felt everywhere, most acutely in densely populated cities. Sometimes society is disrupted by more localized phenomena, such as wildfires, floods, tornadoes, or earthquakes. Not to mention war, going on somewhere always, and in some places for protracted periods.

For all these reasons and more, humanity is desperate for transformation. Our way of life is proving to be unsustainable. We need to reimagine how we live our lives. Now more than ever, we need the bubbling transformative power of fermentation.

. . . . . .

I definitely do not wish to suggest that the simple act of fermenting in your kitchen will save the world. I wrote in *Wild Fermentation* of fermentation as "a form of activism." I stand by this notion, but not because there is anything inherently political about fermentation.

People can be narrow in their focus, and often the reasons people ferment are specific, for example preservation of garden vegetables, or a desire to improve health, or the pursuit of compelling flavors.

The only thing that makes do-it-yourself fermentation radical is context: our contemporary system of food mass production, which is unsustainable in so many ways. Our dominant food system is polluting, resource-depleting, and wasteful, and what it produces is nutritionally diminished, causing widespread disease. Perhaps even more profoundly, it deskills and disempowers people, distancing us from the natural world and making us completely dependent on systems of mass production and distribution—which are fine as long as they function, but are vulnerable to many potential disruptions, from viral pandemics to fuel shortages or price spikes to war and natural disasters. Expanding local and regional food production, and in the process transforming the economy that goes along with it, is the only real food security.

Food and food production are quite profound as we try to shift our relationships to the Earth and to one another. Food can be a means of building and strengthening community. Producing food is a very ethical way to channel one's energy. You're doing something productive and creating some sustenance for yourself and other people. Localizing food production stimulates local economies more broadly, by recirculating resources rather than extracting

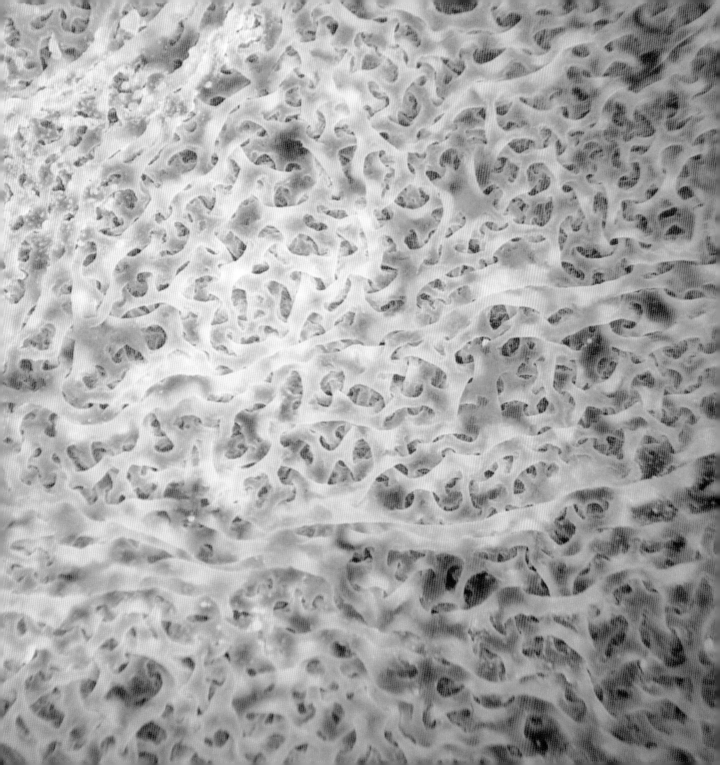

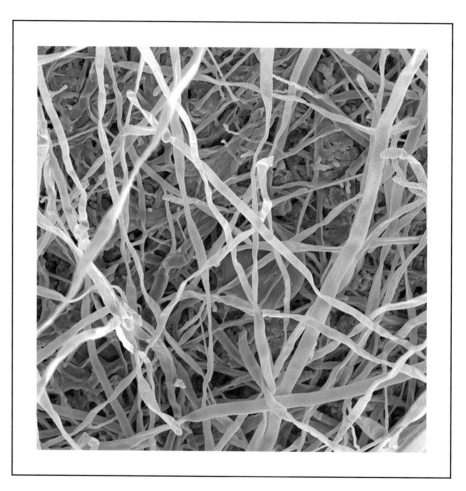

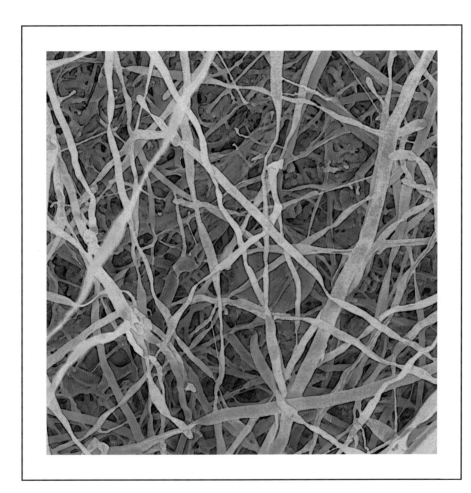

them. Getting involved in food production can also help us feel empowered and more connected to the world around us.

We must find ways to reorganize our society, to move from being driven by resource extraction toward a dedication to regeneration. I do not mean to sound preachy, here. I'm not entirely living what I advocate, so I can be viewed as a hypocrite. I mean, I fly more than almost anyone else I know in my fervor to share fermentation. And in my home life in a rural area, I drive almost everywhere I go. I greatly admire people who live their ethos and entirely eschew planes, or all fossil-fuel-driven transportation, but in my life I have defaulted to the path of mobility, like most.

We, including me, definitely need to slow down our mobility and along with it our expectations of growth. What we need is contraction: each of us leaving a much lighter footprint, with more equitable distribution of resources. We also need to shift from our focus on individualism to more cooperative, collaborative models for working together and mutual aid. I have no grand plan, and in our current corporate-dominated political system I've become skeptical of grand plans. But moving in this direction definitely involves getting more people plugged into the earth and life around us, the plants and animals and fungi and even the bacteria. This is what food production forces us to do—to be more tuned into our environment. Certainly this is true of fermentation.

# the war on bacteria

Meanings and metaphors multiply. Fermentation of foods and beverages breaks down nutrients into simpler, generally more accessible forms. It can also break down toxic compounds into harmless substances. Metaphorical fermentation causes a similar breakdown. Old structures, ideas, beliefs, and paradigms inevitably give way. But fermentation is never a dead end. Whatever breaks down gives rise to new forms. And these too shall break down, and on, and on.

One big paradigm that is breaking down in the present is what I call the War on Bacteria, a public health campaign and ideology that emerged out of the early triumphs of microbiology in identifying pathogenic organisms and fighting them. The War on Bacteria flourished throughout the twentieth century, as science joined with industry and government to combat bacterial illness through chemical warfare, accompanied by a barrage of propaganda encouraging us to consider bacteria as enemies to be exterminated. The War on Bacteria started with lifesavers, such as chlorinated water and antibiotic drugs, and grew into contemporary excesses, such as the routine feeding of antibiotics to livestock to make them grow faster and antibacterial chemicals in soaps and many other household products. Most of us born in the twentieth century only ever heard of bacteria in the War on Bacteria context, as pathogens

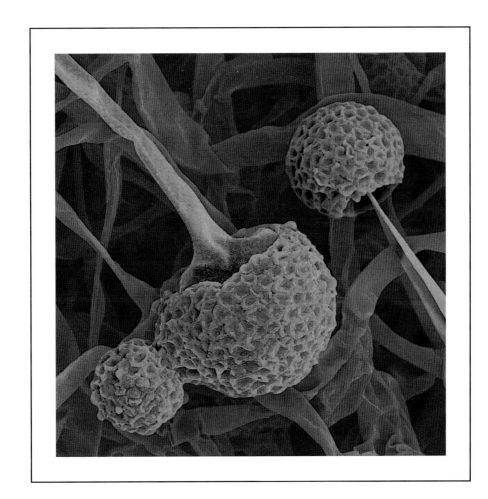

to be avoided as much as possible, and, when encountered, to be eradicated by any means necessary.

In our historical context, following more than a century of the War on Bacteria, the very idea of fermentation, cultivating bacteria and fungi in foods and beverages, gives rise to difficult conceptual questions. People often project the fear they've been taught to have about bacteria and fungi upon fermentation. A common question I've fielded over the years is: "How can I be sure I have good bacteria growing in my jar of fermenting vegetables, and not some dangerous bacteria that might make me sick, or even kill someone?" The biggest reason you can be sure is that there is no case history of food poisoning or illness associated with fermented vegetables. Anywhere.

Fermented vegetables are among the safest of foods because the process is self-protecting, in that the lactic acid that develops rapidly kills off any cells of potential pathogens that might be present, because (conveniently) none of the pathogens can tolerate an acidic environment. While the fermentation of meat, fish, and milk does not quite match the safety record of fermented vegetables, they too are extremely safe, and proper fermentation enhances the safety of these high-protein animal foods. The safety of fermented foods and beverages is intrinsic to their long-standing popularity, and yet in our time many people cannot help but feel anxious about them.

Scientific understanding of bacteria has shifted dramatically in recent decades. Beginning with Pasteur and throughout the twentieth century, microorganisms were studied by isolating, growing, and observing a single species, or sometimes the interactions of two or three. New methods of genetic analysis have enabled microorganisms to be studied as dynamic and complex communities, as they exist everywhere in nature. These communities vary wildly, each uniquely adapted to its specific niche, and still possessing vast adaptive potential. Bacteria exhibit incredible genetic flexibility, with shape-shifting capabilities to incorporate and remove genes that leave microbiologists questioning the applicability of fundamental concepts such as "species." There is a broad scientific recognition that prokaryotes (single-cell organisms without a nucleus) such as bacteria were the earliest form of life on Earth, and remain essential symbiotic partners of all multicellular life-forms.

Yet in the popular imagination, bacteria continue to be associated primarily with danger, disease, and death, and all-out warfare against them only intensifies. We see continued overuse of antibiotics in health care and agriculture, in the face of widespread evidence and recognition that they are being overused. Triclosan and other antibacterial compounds keep finding their way into an ever-widening array of household products, including soaps, detergents, cleaning products, toothpastes and mouthwashes, moisturizers and cosmetics, garbage bags and plastic wraps, and even textiles

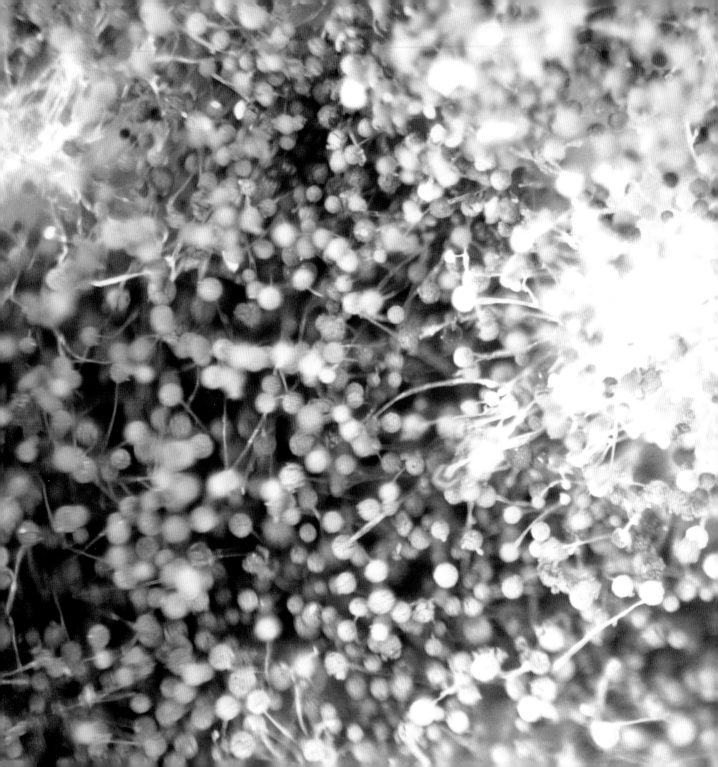

and building materials. Despite evidence that widespread use of these chemicals is hastening the evolution of resistant bacteria, the industries that produce and use them profit by stoking deep-rooted fears, aided and abetted frequently by regulators who come directly from the very industries being regulated: the insidious government-lobbying-industry "revolving door."

I'm no purist on the use of antibiotics, or anti-bacterial cleansers, or anything. I just think it makes sense to limit their use to the situations in which they are most necessary, for two reasons: to minimize disruption to healthy microbial communities; and to preserve the power of the antibiotic compounds by slowing the evolution of resistant strains. I want the surgery team to wash with anti-bacterial soaps, and I don't want their effectiveness in that context to be diminished by the use of the same compounds in households, schools, and businesses everywhere. "Some of our most powerful drugs are becoming useless," warns the Infectious Diseases Society of America. "If we do not act immediately we face a future that may resemble the days before these 'miracle' drugs

were developed; one in which people die of common infections, and where many medical interventions we take for granted—including surgery, chemotherapy, organ transplantation and care for premature infants—become impossible."[4] Antibiotics have saved me, more than once. But as a guiding principle, I would say that as much as possible antibiotic drugs should be targeted and specific, rather than broad; and they should be prescribed and used much more judiciously. The broader the antibiotic activity, the greater the collateral damage.

The COVID-19 pandemic ushers in a new period in which the War on Viruses supplants the War on Bacteria. I certainly am following recommended precautions, and I have been living for three decades now with another notorious killer virus, HIV, thanks to anti-retroviral drugs for the last two of those decades. But even as someone who has lived through terror and near-death by virus, I have to recognize, and wish to point out, the importance of viruses as a group to our existence. One type of virus, phages, which target bacteria, are thought to be the most numerous life-form on Earth, more numerous than all others combined, including bacteria. Everywhere bacteria are found (everywhere), phages are there with them. Phages and other viruses are as integral to the complex biological web that sustains us as bacteria; it is the totality of this web that enables us to exist.

Reflecting War on Bacteria logic, people often imagine that in order to safely or effectively ferment something, they must do so using vessels

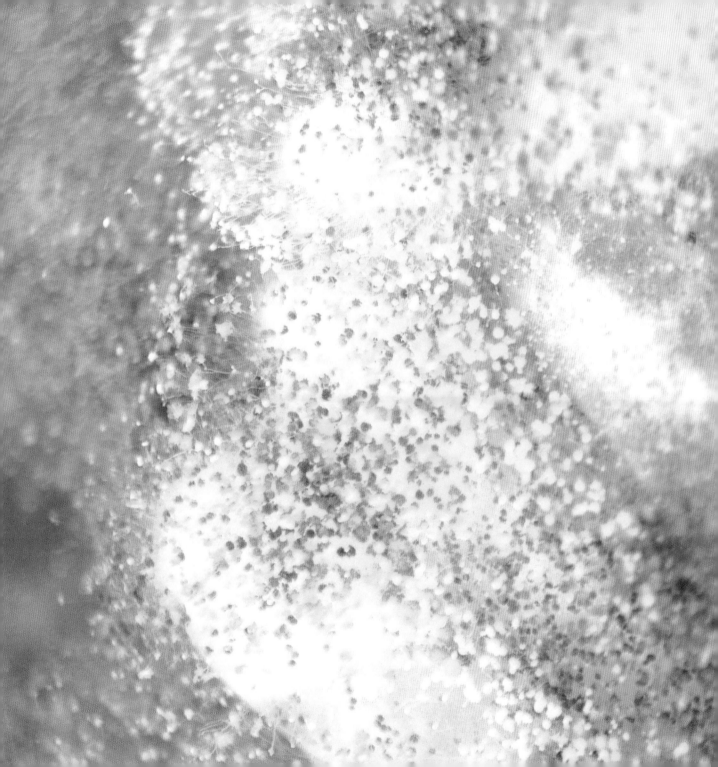

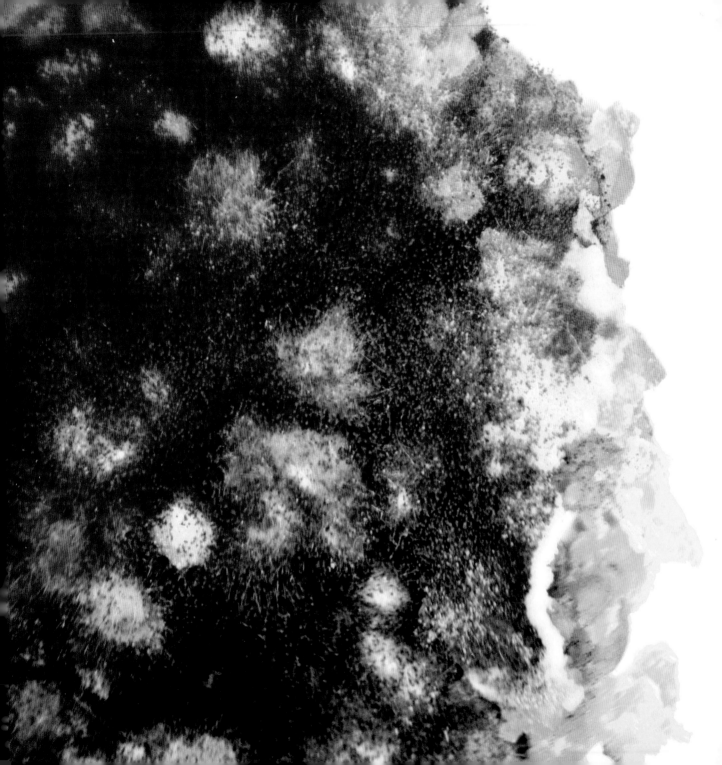

and tools that have been thoroughly sterilized. Sterilization equals purity, the absence of contamination. Certainly most industrial or even micro-scale brewing, winemaking, cheesemaking, and other types of fermentation rely upon various aggressive chemical protocols to sanitize and disinfect. And yet a sterile, microbe-free environment beyond certain extremely limited parameters is the realm of fantasy.

## purity and contamination

A defining quality of purity is that it cannot be achieved. It is an aspirational goal that can never be reached. Gold is considered pure if it is 99.9 percent pure. Most chemicals are nowhere near that pure and are graded in terms of how close to purity they come. Products of agriculture are never pure either. The US Food and Drug Administration's "Defect Levels Handbook" contains a chart of "Levels of natural or unavoidable defects in foods that present no health hazards for humans," allowing levels as high as 2 percent of "mammalian excreta," as well as acceptable levels of insect fragments, insect and rodent "filth," fly eggs, maggots, and more in various foods.

You can be meticulously clean, and still your environment will never be pure, because nothing ever is. Especially the sponge you are cleaning with, which researchers found to be populated with

"higher bacterial diversity than previously thought," according to a 2017 genetic sequencing study.[5] Microbial biodiversity is the matrix for all life. It is neither possible nor desirable to escape it.

More and more evidence suggests that *inadequate* exposure to diverse microorganisms is driving epidemics of allergies, asthma, and other autoimmune diseases. Childbirth is a major event for bacterial exposure, and with rising cesarean rates, many babies miss that all-important dose. Breastfeeding continues to introduce bacteria with the milk, and many babies do not receive that. Some children rarely or never get to play in earth, or with animals, or even with other children. Some overprotective parents try to keep their babies from exploring the world with their mouths, another important route of microbial exposure. Despite the indoctrination most of us received to the contrary, in general we are enhanced by biodiversity much more than we are threatened by it.

The counterpoint to purity is contamination. Where purity is an impossible state, contamination is inevitable. The word comes from the Latin *contaminare* (to defile), a conjugation of *con* (with) and *tangere* (to touch). We live among other beings, and contact is inevitable. The question with contamination is not if, but how much? Biodiversity is an immutable fact, varying only in terms of the composition and population densities of microbial communities in different environments.

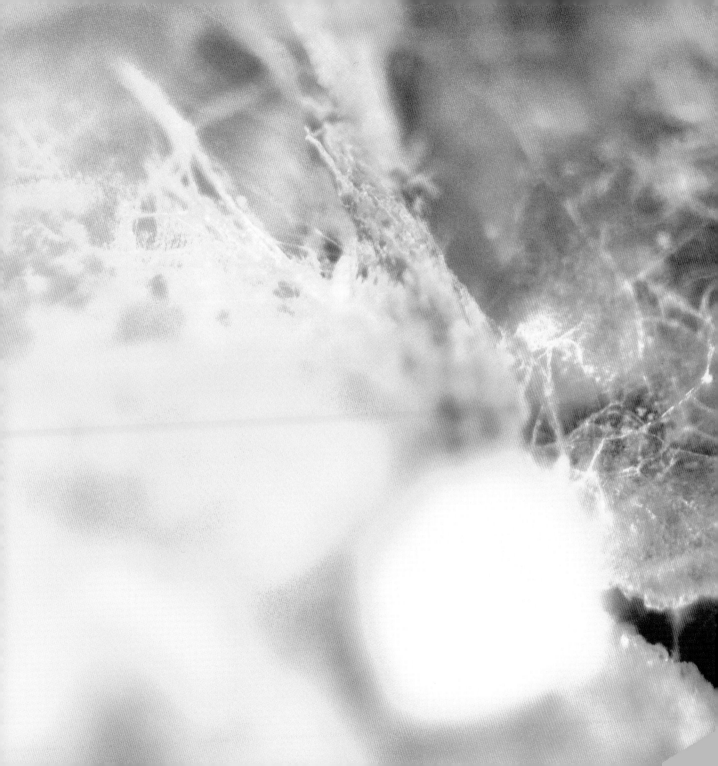

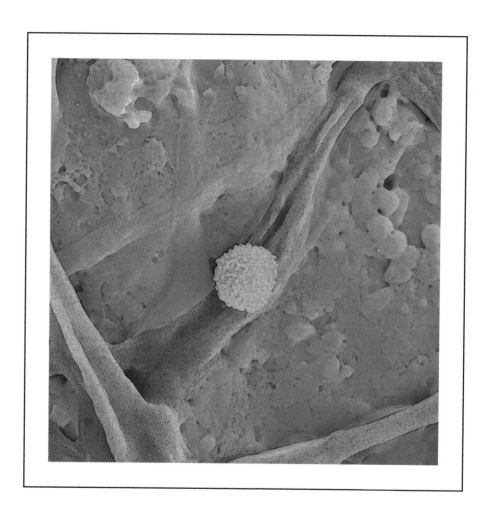

And yet "germs" loom large in our collective imagination. *Germ* is a vague term describing fertility, from the Latin *germinis* (to sprout or germinate), which comes from the Proto-Indo-European root *gen* (to beget or bear). Since the emergence of microbiology, *germ* has come to encompass bacteria, viruses, and other microbial beings that we understand to be the cause of disease, the microbe germinating within us to create the disease.

We fear germs and try our best to avoid exposure to them. The chemical industry has fueled and exploited this fear, offering us an endless array of products promising to keep us safe by eradicating germs from our bodies and environments. The promise of protection by eradication is nothing more than a fantasy, and in fact eradicating microorganisms would be suicide, for "we" cannot exist without "them." Bacteria, viruses, fungi, and other microbes are part of us; or, perhaps more accurately, we are part of them.

## microbiopolitics

We live our lives in a sort of microbial force field, a complex community of bacteria, viruses, fungi, and other organisms that live upon and within us, built up over a lifetime of exposures, winnowed by chemicals, diet, and other selective environmental forces.

These organisms are part of us, in that they enable us to effectively function, and they are integral to many of our bodies' regulatory processes, in ways that we are just beginning to realize. Microbial exposure stimulates the development of our immune systems, and bacteria in our intestines work with our cells to facilitate immunity and digestion, synthesize essential nutrients and chemicals, and help regulate many organ systems, including the brain. Healthy microbial communities on our skin and in our mouths, noses, and other orifices are our first line of defense, warding off other organisms to preserve themselves and, by extension, us. Biodiversity quite literally protects us.

The way the microbial communities that are part of us protect us is mirrored by the protective role of microbial communities in fermentation. In sauerkraut, lactic acid bacteria rapidly dominate the microbial community of the salted and submerged shredded vegetables, and acidify the environment, thereby eliminating acid-intolerant pathogens. The same and related transformations occur in many other realms of fermentation, including cheesemaking. Anthropologist Heather Paxson has studied the revival of artisanal cheesemaking in the United States, identifying "a clash between a regulatory order bent on taming nature through forceful eradication of microbial contaminants—a *Pasteurian* microbiopolitics—and a *post-Pasteurian*, post-pastoral alternative committed to working in selective partnership with microscopic organisms,

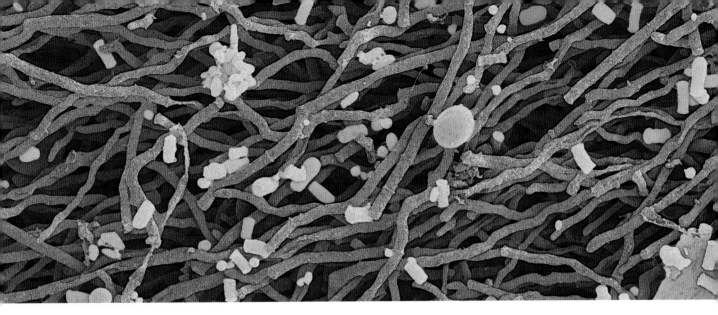

figured as agents of a nature that is not fully objectified and never fully separate from human enterprise. Whereas a Pasteurian approach treats the natural world as dangerously unruly and in need of human control, a post-Pasteurian view emphasizes the potential for cooperation among agencies of nature and culture, microbes and humans."[6]

I like Paxson's word *microbiopolitics*. The word itself suggests the need for ecological thinking and biodiversity, because of the fact that we are so intertwined and interdependent. "Taming nature through forceful eradication" seems like a losing microbiopolitical strategy. Eradication includes us! We need to be more judicious with our use of antibacterial, antibiotic, and antifungal chemicals, ensuring they are as targeted and specific as possible, rather than broad. The forcible eradication of the microbial communities that

are part of us is severely detrimental, and if totally realized surely fatal. The fantasy of purity is a futile pursuit.

In terms of literal fermentation, the "pure culture" starters like yeast or various other isolated bacteria or fungi that many contemporary fermentations rely upon are new inventions of science, a departure from the ancient traditions of fermentation. Until Pasteur first learned to isolate and propagate yeast and other organisms 150 years ago, fermentation traditions everywhere, since the beginning of time, involved mixed cultures, meaning communities of organisms, as they are found in nature on grapes, in raw milk, on vegetables, on wheat, on rye, et cetera, and present in all environments.

The Old World way of making wine, which worked well enough to make a product that was universally enjoyed in grape-growing regions, and fetishized by elites across much of the globe, was to crush grapes and let them sit with their skins and stems until they began to ferment. Easy. Pure-culture yeast has lessened variability perhaps, and made it easier to scale up wine production, but it also made the process much more complicated. You need chemicals to kill the organisms on the grapes. You need to buy yeast, which had previously been part of the grapes. And because you are using a pure culture, it is vulnerable to other organisms, so you need more chemicals to sanitize your vessels and tools. Mirroring our agricultural model of monoculture, it is the contrived condition of trying to get just a single

organism to grow, rather than the complex community present on whatever we are fermenting, that drives the logic that everything needs to be sterilized. Whatever is not pure is contaminated.

## purity and contamination as political weapons

Fantastical as the concepts of purity and contamination are, they continue to be applied in very tangible ways, shaping our thinking and understanding of the world, informing ideologies, ethics, and cultural struggles, and driving laws and policies. Here in the United States and around the world, we watch as nationalist political movements project their race/nation/culture/blood as pure, and blame some other race or ethnic group(s) for threatening to contaminate that purity. Just as people can project irrational fear of bacteria upon fermentation, people can project any number of irrational fears of contamination by the other upon the race/nation/culture. We humans seem to have a propensity to imagine us-versus-them dynamics, and fear of the other has been used repeatedly, in all sorts of different geographic and historical contexts, to whip up fear. The specific sources of contamination may shift, but the threat of it remains a potent political weapon.

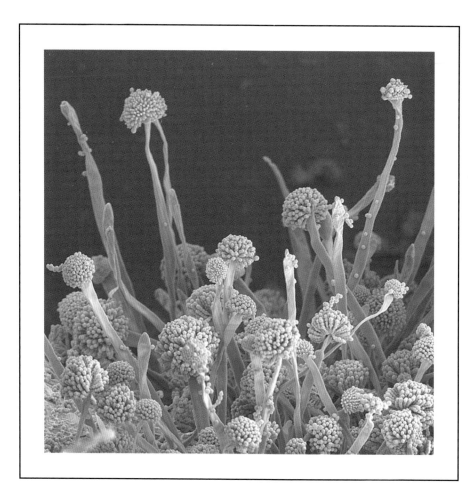

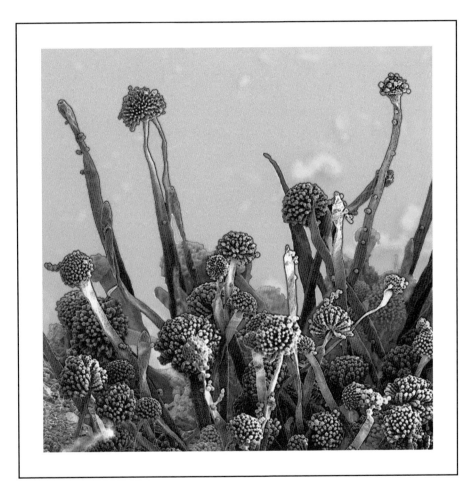

We hear so much fearmongering: Beware the Chinese who brought the virus! Beware the onslaught of refugees from Central America! Beware refugees from the war in Syria! Beware voting fraud! Beware transgender people trying to get into your restroom! Beware less qualified minorities taking what's rightfully yours! Beware the Jewish conspiracy! Who will be the scapegoat next time?

Like people who are different from us, microorganisms are a fact of life. We live in a contaminated world of constant microbial exposure. We come from bacteria, in a long-term evolutionary way; we live among them and viruses and many other microorganisms; and we depend upon them all for functionality and survival. If purity means a state devoid of contamination, that is pure fantasy.

Microorganisms are an essential aspect of our existential context. We can no longer imagine them as our mortal enemies to be destroyed by any means necessary. Instead, we must recognize them

44

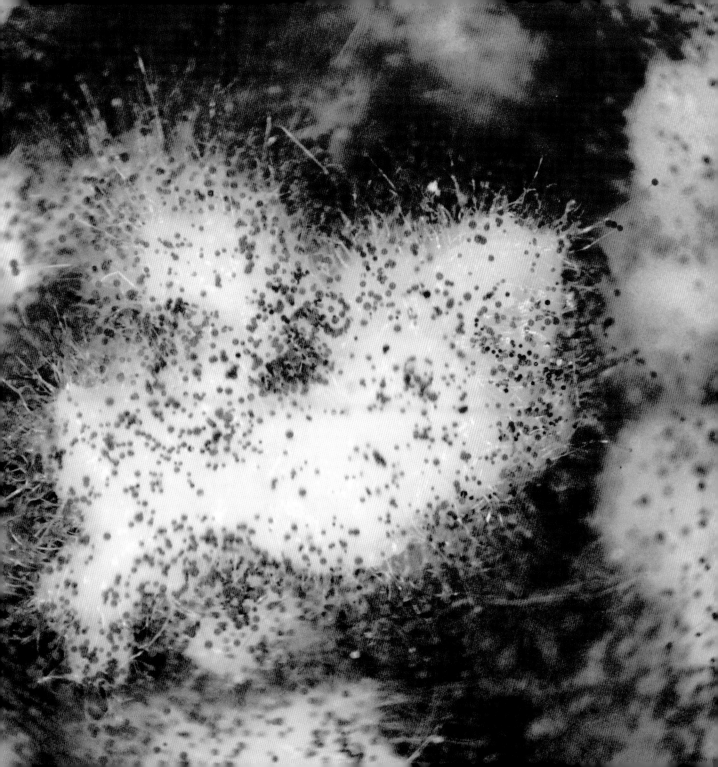

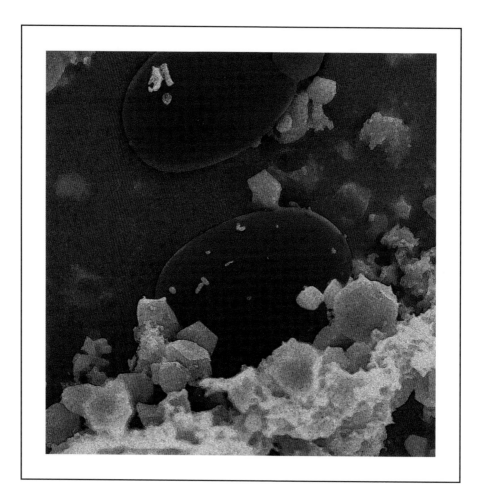

as partners. We can nourish them with a fiber-rich diet, which feeds the bacteria of the large intestine, thus supporting gut microbiome health and biodiversity. In addition, we can try to build biodiversity by eating live *probiotic* fermented foods.

We can also look to our microbial partners for inspiration. Their genetic flexibility—made possible by genes that are not contained in a nucleus, and the various means bacteria and viruses have for genetic transfer—gives them unrivaled evolutionary potential, and great powers of adaptability and resilience. Bacteria have been able to adapt to every known ecosystem; some are even classified as "extremophiles," thanks to their ability to tolerate high or low temperatures, radiation, pressure, or other environmental extremes. Bacteria also possess decentralized intelligence and communication systems described as "quorum sensing," chemical signaling that enables them to detect their density in an environment and facilitate coordination. Everywhere bacteria exist, there are even more numerous viruses, the phages, which can attack and destroy them. And fungi create vast networks capable of distributing nutrients, water, and chemical signals.

The unseen microbial world is so rich, and we are really just beginning to get to know it. As we learn more about this world, we must reclaim our ancestral connection to it. Bacteria, viruses, fungi, and other microorganisms are not our enemies. Their absence is not a state of purity but rather a vacuum, a contrived condition that

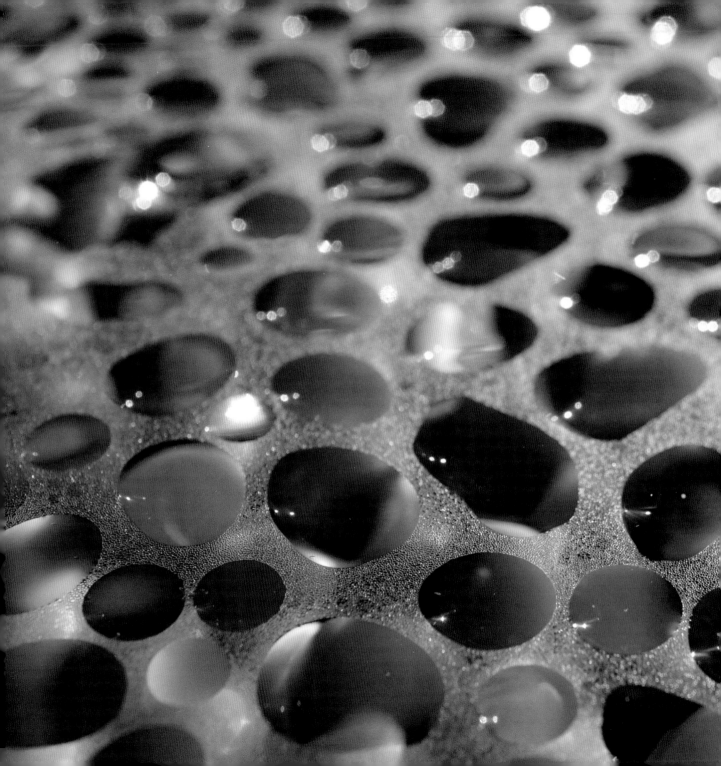

takes extraordinary effort to maintain. Far from contamination, the presence of microorganisms in cohesive structured communities is a powerful force of equilibrium, playing a protective and regulating role, in our intestines, in the soil, and on the Earth as a whole.

Our continued existence is threatened by many factors of our own creation. This includes not only climate change but also the explosion of human consumption, driving deforestation, resource extraction, and mass extinctions. Simultaneously we face persisting white supremacy and patriarchy, growing economic disparities, and growing political violence. Survival, if even possible, will require a great deal of adaptability to change. Bacteria and fungi and the broader microbial communities in which they exist exemplify adaptability and constant change; and fermentation offers potent metaphors for imagining change and communicating about it so that we may take collective action.

## the fallacy of pure blood

The notion of "pure blood" is the fallacy of purity that has probably been most destructive over time, providing the rationale for humanity's greatest horrors, from chattel slavery and ongoing white supremacy to the Nazi holocaust and other ethnic genocides going

on all the time around the world. Whiteness itself signifies the fantasy of purity, whether racial purity, or the purity of white sheets, or white flour, or white sugar. In contrast stands darkness, signifying contamination. The other must be dehumanized, whether through genocide, enslavement, legal exclusion and intimidation, mass incarceration, police brutality, or simply the insidious everyday forces of systemic racism.

Legally forced segregation; laws against interracial marriage; the fact that mixed progeny of whites and other-than-whites have widely been considered other-than-white; lynching Black men to protect the virtue of white women—all of these expressions of white supremacy have been justified as necessary to maintain racial purity against contamination. Ideas of racial and ethnic purity are espoused not only by white supremacists but sometimes also by people of disparate racial and ethnic backgrounds.

In this realm, too, purity is utter fantasy. We are each the unique amalgam of countless generations of genetic mixing. Our shared human roots go back to Africa, and as genetic diversity has increased over time, humanity has continually mixed and remixed. According to geneticist Alan Templeton,

> *Human "races" are not distinct lineages, and . . . this is not due to recent admixture; human "races" are not and*

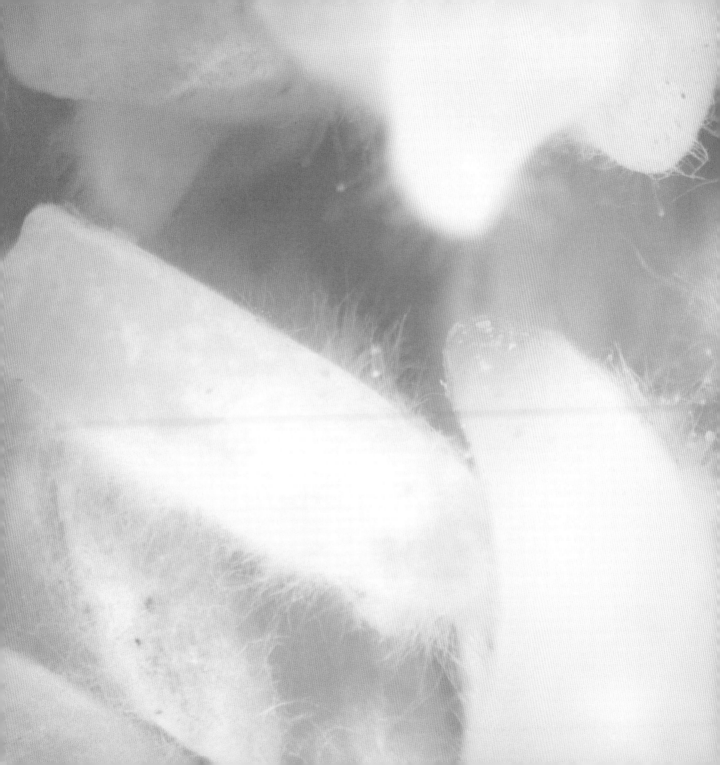

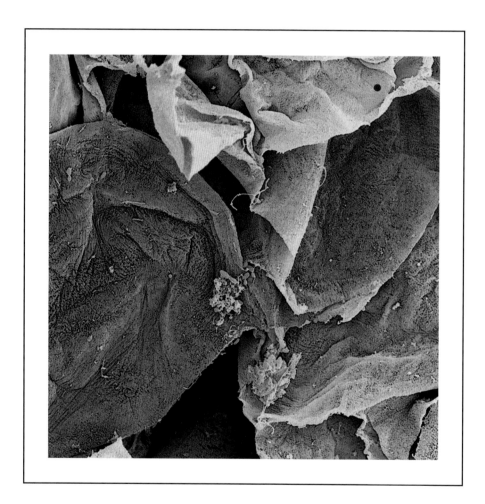

*never were "pure." Instead, human evolution has been and is characterized by many locally differentiated populations coexisting at any given time, but with sufficient genetic contact to make all of humanity a single lineage sharing a common evolutionary fate.[7]*

As genetic testing has become widespread, people are frequently surprised at what they learn. No matter how strong people's sense of racial or ethnic identity, everyone's ancestry is muddled. If purity in general is unattainable, genetic purity is an outright oxymoron because the specific advantage conferred by sexual reproduction is genetic mixing.

I think in most cases people who espouse ideals of racial or ethnic purity are really craving some kind of cultural purity, which race or ethnicity overlaps with and signifies. But how could culture ever be pure? Never fixed, culture is continuously unfolding. I don't mean to dismiss in any way cultural identity, which can be powerful. Culture connects us to the past and to people like us, and to useful information, and important stories, and so much more. In our midst in any given place are all sorts of cultural and subcultural niches, where people find community with others with whom they share some cultural identity. Some people find refuge in a specific subcultural bubble; many feel connected to multiple cultures and subcultures, intersecting identities navigated and manifesting in

infinite unique ways; too many people feel like they don't quite fit in anywhere.

Many ancient cultural traditions have been completely lost through assimilation and mass migrations, voluntary or forced, as well as genocides. Many other cultural traditions that endure are struggling for survival, and that idea is a big motivation for my work as a fermentation revivalist. Fermentation techniques are vital cultural information. Fermentation is not one singular body of knowledge; to the contrary, it comprises a broad range of extremely diverse practices, integral to food traditions everywhere, that evolved differently in different places as specific manifestations of place. This cultural distinctiveness must be recognized, celebrated, valued, and most of all used and shared. Through disuse, this knowledge can easily be lost.

My cross-cultural exploration of fermentation has vividly illustrated for me how extensively cultural practices spread and morph and get variously interpreted, echoing what I have read about the spread of cultivated crops, domesticated animals, languages, religions, music, art, literature, technology, economic and scientific ideas, and other realms of culture. You can do your best to live in a bubble, but there is nothing pure about any cultural bubble; it is the amalgam of diverse influences, and diverse influences continue, always. A characteristic of bubbles to bear in mind is that they always burst.

# the fantasy of a
# perfect protective border

Closely related to the fallacy of pure blood is the fantasy of a perfect protective border. Political borders are contrived, arbitrary, and imposed. The inhabitants of many border regions experience every day the porosity of borders, with families, jobs, and other social, cultural, and economic aspects of life spanning the divide. Inhabitants of some border regions have lived through shifts of national control of the places where they live their lives. Life goes on. Where borders are imposed in an absolute way, they leave deep scars in disrupted ecologies and cultures, and severed relationships and families.

"Build the Wall" and equivalent slogans and policies are futile attempts to make a border absolute, separating territory and people in black-and-white ways. But in reality a border is a gray area. Just as the edges of ecosystems are always especially biodiverse—for instance, where water meets land, or forest meets field—so too are borders, where national identities, cultures, economies, and languages constantly mingle and cross-pollinate. The idea that either side of a border embodies some pure identity distinct from the other is a fantasy. Some may imagine that asserting absolute territorial control will result in a condition of purity protected from contamination, and that this will make us safe, but lived reality is much more complicated.

# clean food

Another way that notions of purity get applied is in the realm of food. People can be harshly judgmental about how other people eat. I've seen more than a few otherwise thoughtful and compassionate people express nothing less than revulsion toward obese people, judging them for their perceived lack of self-control or self-regard. I've felt judged myself by vegetarians for eating meat. And much more often, I've witnessed aggressive carnivores mock, dismiss, or disrespect vegetarians and vegans.

Sometimes people think of the kind of food they want to eat as "clean," contrasted with the food they are seeking to avoid, which is "unclean." Gluten-free, or dairy-free, or vegan, or paleo, or raw, or Kosher, or Halal, or whatever food embodies the dietary values we are assigning to good, is clean. Gluten, or dairy, or animal products, or grains, or cooked foods, or non-Kosher, or non-Halal foods are dirty.

One interesting aspect of writing about fermented foods and beverages, which are integral to food traditions everywhere and can be incorporated into almost any dietary ideology, is that I have often had people project their dietary ideologies upon me. I've had people who eat only raw food assume that I do, too. I've had vegans

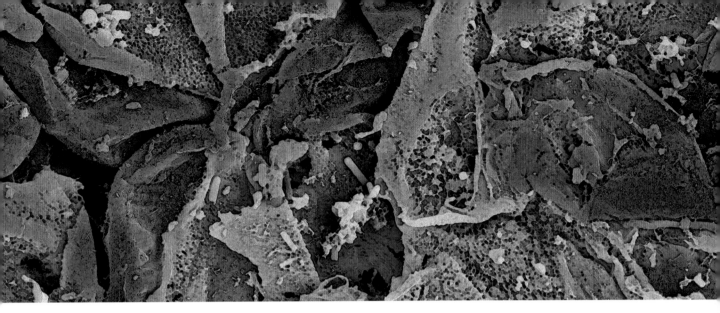

assume I was vegan, and paleo eaters assume I was paleo. I've also had non-Jews who knew I was Jewish assume I was Kosher.

The reality is that I love food quite broadly and do not subscribe to any specific dietary ideology, other than a preference for whole foods (products of nature or agriculture, as opposed to fragments refined or extracted from them), and an ongoing obsession with learning about all the varied transformative processes (such as cooking, drying, milling, soaking, sprouting, and fermentation) by which people in different cultural traditions turn the raw products of nature or agriculture into all the delicacies we love to eat and drink. When possible, I like to enjoy copious amounts of fresh vegetables along with whatever meat, eggs, cheese, grains, beans, or fermented goodies I eat. I stay away from fast-food chains, but generally I'll eat whatever people serve me, and I'll eat out wherever

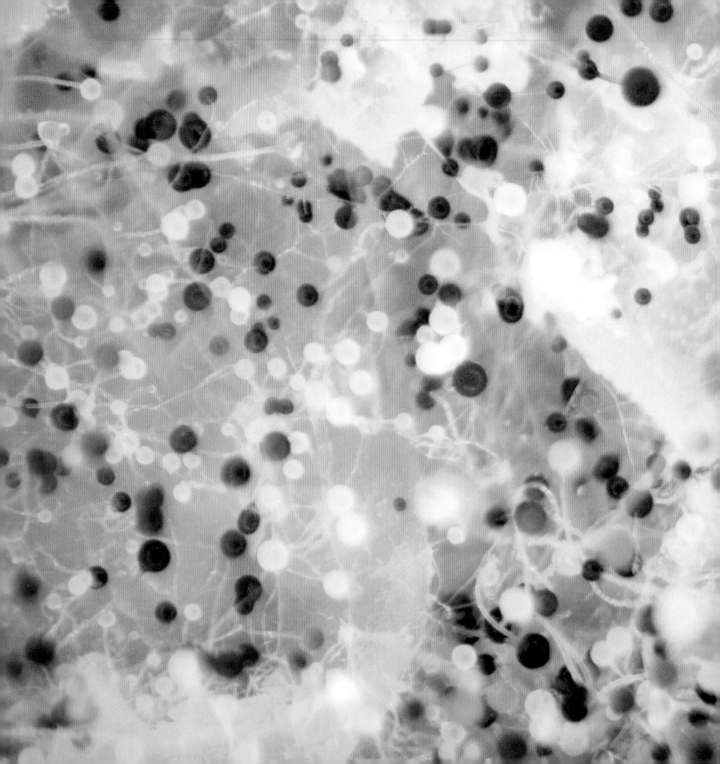

my companions want to go. I like to go with the flow, and food is such an important part of how we share culture and socialize.

I did for a few years follow a very restrictive interpretation of a macrobiotic diet, centered on whole grains, along with beans, steamed vegetables, ferments, and very few fats, no dairy or eggs, and only rarely fish. For most of that time I completely avoided sugar and any foods with sugar added. I lost a lot of weight, and I felt really great, which kept me following the diet. The biggest downside was that food became more personal and specific, and less social. My family and friends didn't know what to make for me, so many of them stopped inviting me for meals. I tried to steer outings to accommodating restaurants and was always requesting simplified dishes. Gradually I loosened my restrictions, until they fell away and I ate whatever I wanted.

Eventually I came to question some of the tenets of the diet. Macrobiotics dovetailed nicely with anti-fat nutrition ideas that dominated late-twentieth-century

thinking. I have since then come to view fats as essential, both as building blocks of flavor and as vital nutrients themselves, as well as vehicles for other nutrients that are only soluble in fat. And while a diet without stimulants might be perfect for the contemplative life of a monk, spices, alcohol, coffee, tea, chocolate, sugar, and so on have been sources of great pleasure to me, as for many people, even with their potential to be used in excess and abused. That said, I credit macrobiotics with a lot, not the least of which is eating food very slowly, really breaking it down by thoroughly chewing each bite before swallowing.

At the height of my macrobiotic period, when I was going to events at the New York Macrobiotic Center and meeting families raising kids in a macrobiotic context, I remember how lucky I imagined those kids to be because they were not being raised on sugar, how pure they were in a way that I never could be, having been contaminated by addictive sugar and processed foods introduced to me by my family and the larger culture in which we existed. In retrospect, it seems obvious that I was seeing the situation from within the bubble. Those kids all existed within the same larger culture that I did, and were exposed to the insidious marketing aimed at kids, even if only reflected through less-protected others. These kids had grandparents and cousins and went to school and probably watched TV. Their parents did not control every moment of their lives, and at some point they had opportunities to eat cookies,

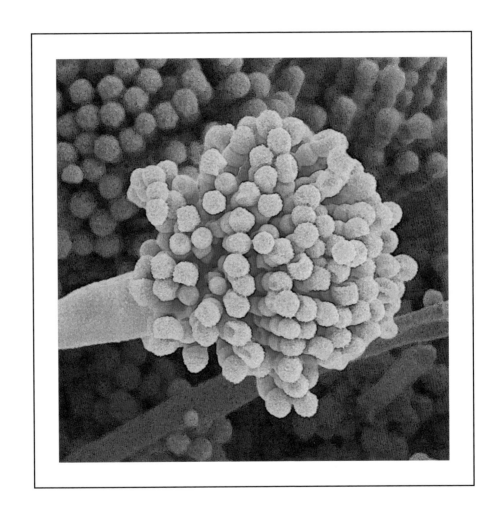

candy, and ice cream. Maybe it became a regular covert activity, something shameful. No matter how protected any child is, a contamination as ubiquitous as sugar is inevitable (not unlike the case of microorganisms).

For me at that time, clean would have meant food without refined grains or sugar. For some vegetarians I have lived with, clean might mean plant-source foods, along with cast-iron pans and cutting boards that have never been sullied by meat. For people thinking about the effects of agrochemicals on the environment or our health, what they would consider clean food might be that which is free of glyphosate and other chemical residues from pesticides, herbicides, fungicides, and fertilizers. Others might consider clean food to be that which is free of preservatives, or is Certified Organic, or GMO-free, or pasture-raised. For local-food activists clean food might be that which is produced within some maximum distance, deeming as dirty any food transported farther, contaminated by the carbon footprint of transporting it. For labor activists, clean might be food grown and processed by producers who value labor and fairly treat and compensate workers. In relation to food, clean can have many varied connotations.

I am an occasional dumpster-diver. There actually is nothing I am happier to spend money on than good food from the people who produce it, or even one or two steps removed. But when I

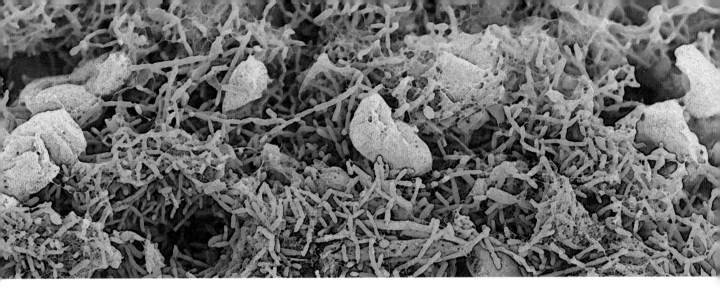

see some of the perfectly edible fruits, vegetables, cheeses, and so much more that gets casually discarded in our wasteful system, it makes me want to rescue, use, and share the discarded resources. I am a fairly picky dumpster-diver, but I have some freegan friends who are less so, and a few who eat almost exclusively from what they can glean from dumpsters and other free-food opportunities. Occasionally some dumpster-obtained food has raised the ire of folks in our community who do not share the sensibilities of the adventurous freegans, and who then demand identifying labels for dumpstered food. For them, clean might be newly produced, rather than diverted from the waste stream.

Clean can signify so many different things about food, and yet food is never clean. Food is never pure. Food always involves ingesting other forms of life. Unintended smaller forms of life are inevitably there, too. Like most other creatures, our greedy hunger is what

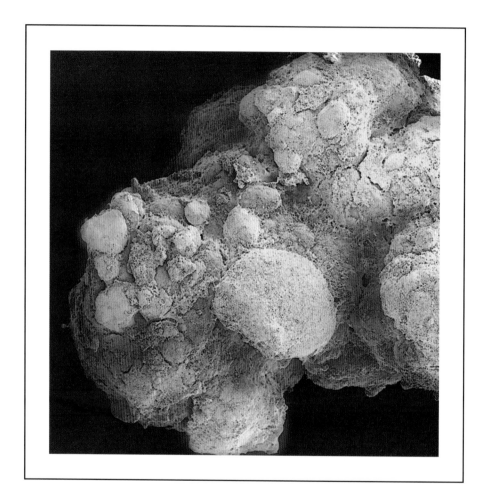

sustains us. Satisfying that hunger is a murderous act at its core, in which we are nourished by nutrients we recycle from former plant, animal, fungal, and bacterial life. There is nothing "clean" about it.

Dividing food into clean versus dirty grossly oversimplifies a multifactorial continuum. The dichotomy itself is unclean, as food is fraught with gray areas and complexities. With food (as with anything), knowledge is power. There are many important qualitative distinctions that run so much deeper than clean versus dirty. I never know exactly what people mean by "clean" food, and I think frequently they presume quite a lot.

## the purity of children

We also apply the concept of purity to children to describe their innocence and lack of experience. I have an old friend whose sister demanded that her family and friends refrain from discussing potentially scary "negative" things around her children, such as illness or death. Events like these are the stuff of life and the substance of family. I agree that it is generally unnecessary and inappropriate to give gratuitous or graphic details to young children, but the facts of illness and death are nothing if not teachable moments. Our objective with children must be to prepare them to function in the

world, not insulate them from it. To imagine that children are so pure and innocent that the most basic realities of life will somehow traumatize them is to project upon them an unrealistic ideal and deprive them of the experiential education we all need.

Children are also frequently viewed as pure in the sense of being untainted by sexuality. I've watched parents shriek in horror and rush to cover their small children's eyes to protect them from nudity, as if seeing a naked adult would somehow contaminate their innocent children. Nakedness itself is not sexuality; it is our most natural state, which some confuse with sexuality. In this case the projection of purity amounts to enforced ignorance.

The idea that young, sexually immature people have no sexual feelings seems to me like denial, and imagining them as pure is wishful thinking. Babies are exploring the world and their own bodies for the first time, with so many discoveries to make and things to learn. But as these uninhibited pleasure-seekers explore their own bodies and inevitably discover genital pleasure, in our society generally their parents tell them not to touch or rub there, as did mine and many others, squelching early instinctual exploration. Our imposing purity upon young children stifles a natural curiosity, represses development, and begins the crippling association between sexual pleasure and shame. Let's educate children about sexuality, not deny its existence.

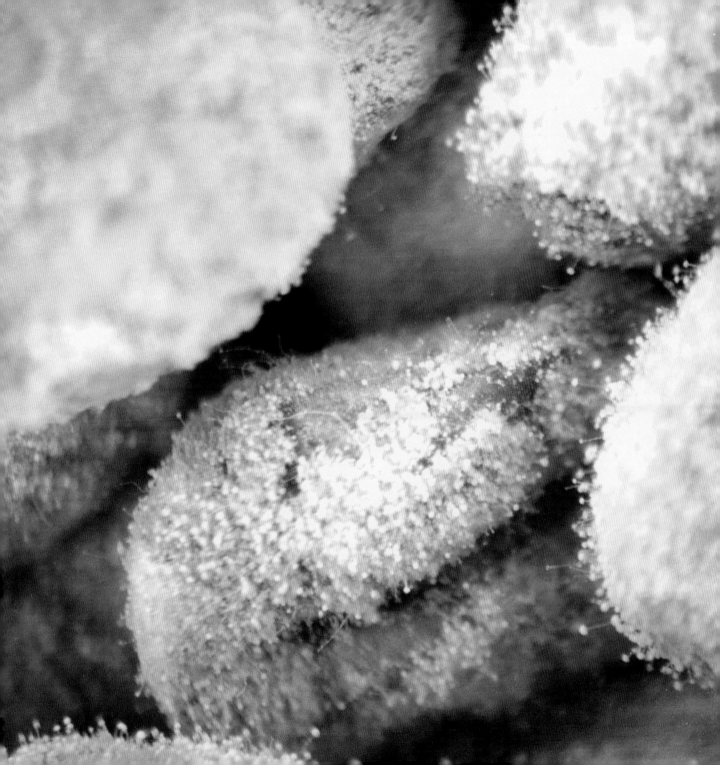

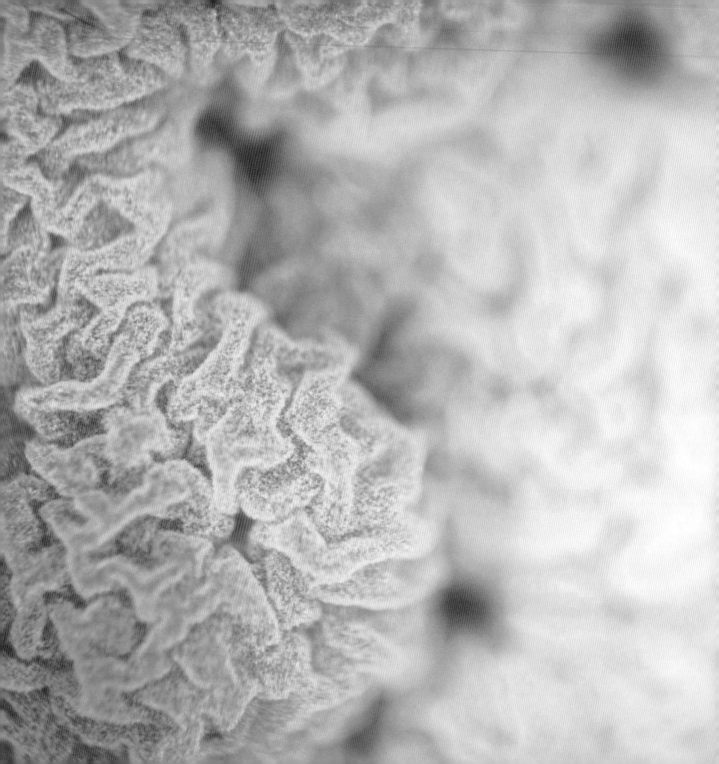

Please do not read into this an endorsement of children having sex, especially with adults, what is known as pedophilia. I am advocating only for the right of children to explore their own bodies. Sexual contact between adults and children is inherently inappropriate because it is so imbalanced in terms of development, knowledge, size, and power. My larger point is that sexual development is an aspect of overall physical and psychological development. When we project and enforce purity upon our young, we deny them the opportunity to develop this important aspect of themselves that generally comes so naturally; and we set them up for future inner conflict, between the feelings and impulses they experience, and what society says these should be.

The counterpoint to sexual purity is contamination, which you'll recall derives from the Latin *contaminare*, to defile. The monotheistic religions use such terms to describe women, though generally not men, who have engaged in sexual intercourse prior to marriage. Young men are expected to be horny and to seek out sexual experience; young women are expected not to, and if they do, they are shamed, shunned, branded with epithets such as *slut* or *whore*, physically and emotionally abused, and even killed.

Fear of sexual contamination of innocent children has frequently been used as justification for the legal exclusion of LGBTQ+ people. Homophobic and transphobic campaigns have attempted to paint

LGBTQ+ people as recruiters, molesters, or unsavory influences upon children. This rationale has been used to justify excluding LGBTQ+ people from teaching in schools, providing foster care, and adopting children, as well as to prevent transgender people from using public restrooms.

......

As I was pondering this section, I happened upon an evangelical Christian tract titled *The Purity of Little Girls*, in which a young single mother recounts her story: "It is not necessary to conclude that I was an unusually depraved child. I wasn't, but I did have the intense curiosity about life's mysteries, that other children have, and, since I was allowed to play freely . . . we children had ample opportunity to say and do a great many things our parents never dreamed of."[8] The moral of the tract is that not only adolescent young women but also younger girls need close supervision and moral guidance. But in laying this out, the evangelical tract acknowledges the universality of "intense curiosity about life's mysteries." Given this fact of life, I draw the opposite conclusion: This curiosity, like any, must be acknowledged and nurtured, and youthful exploration must not be discouraged.

We must educate our young about sex to help them understand their bodies and feel empowered to make good decisions about them. Sexuality is part of the ferment of human experience, in

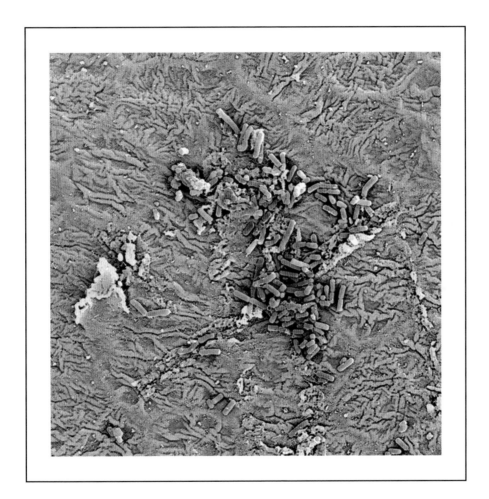

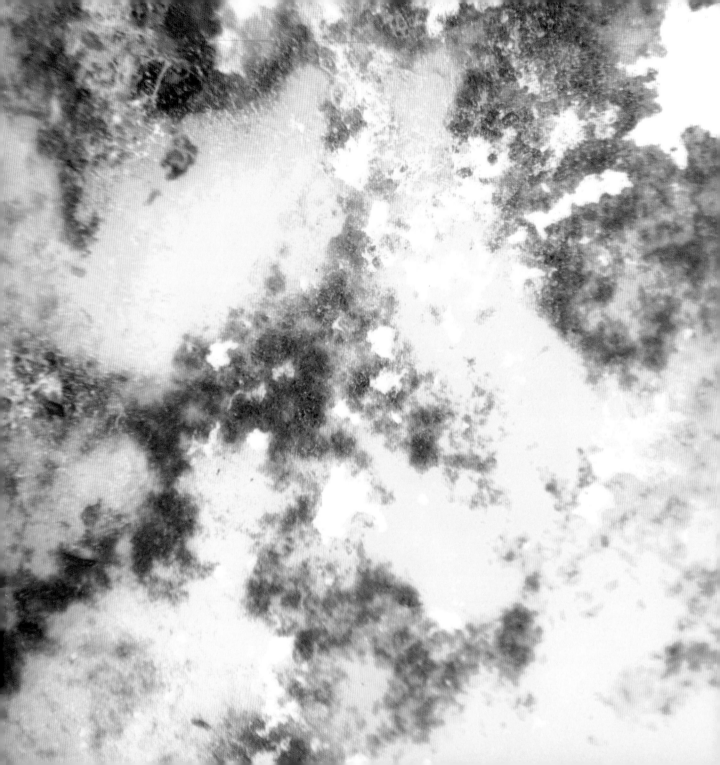

that it can make us so bubbly with excitement, anticipation, and all manner of emotion. Like fermentation, sexuality is a driving life force that cannot be eradicated and persists no matter what measures are taken to suppress it.

## body odor

Closely related to sex are body odors, because smell is such an important part of the experience of sexual attraction, at least for me, and many others. I read about a speed-dating experiment where participants were asked to sleep for a few nights in a clean T-shirt, then at the event the T-shirts were placed in numbered bags and participants met each other based upon mutual smell-attraction. For me, smell alone is not sufficient to make me feel sexually attracted to someone, but it is definitely necessary, and without being drawn to a person's smell, I could never sustain a sexual attraction to them.

Generally I find body odors to be innocuous, and rarely as unpleasant as most of the scents that people wear to mask them. Our culture encourages us to buy deodorants, perfumes, colognes, air fresheners, scented soaps and detergents, and other scented products to mask our body odors, even though we typically shower

frequently. Capitalism convinces us that we cannot live a civilized life without these essential consumer items. If we apply enough scent, then our smell gets covered up, and we temporarily exist in a deodorized state of purity.

I am a hairy, sweaty man. I have a scent, but it is not bad. My mother thought it was, and she tried to get me to wear deodorants as a teenager and young adult. She believed that her persistent obsession with my body's odor was doing me an important favor: "If your mother won't tell you, no one will," she often reminded me. But I always liked the way my body smelled, and generally washed before I ever had a chance to notice it. Furthermore, I hated the smell and the feeling of every deodorant I ever tried. I haven't worn deodorant in my adult life, without complaint except from my mother (who died decades ago). Maybe people are sometimes offended by my smell but are too polite to say anything; I don't know. An old friend of mine, who lived for many years in Germany, was once accosted on a subway in Berlin by an older woman who told him how rude it was for him to be on the train with garlic on his

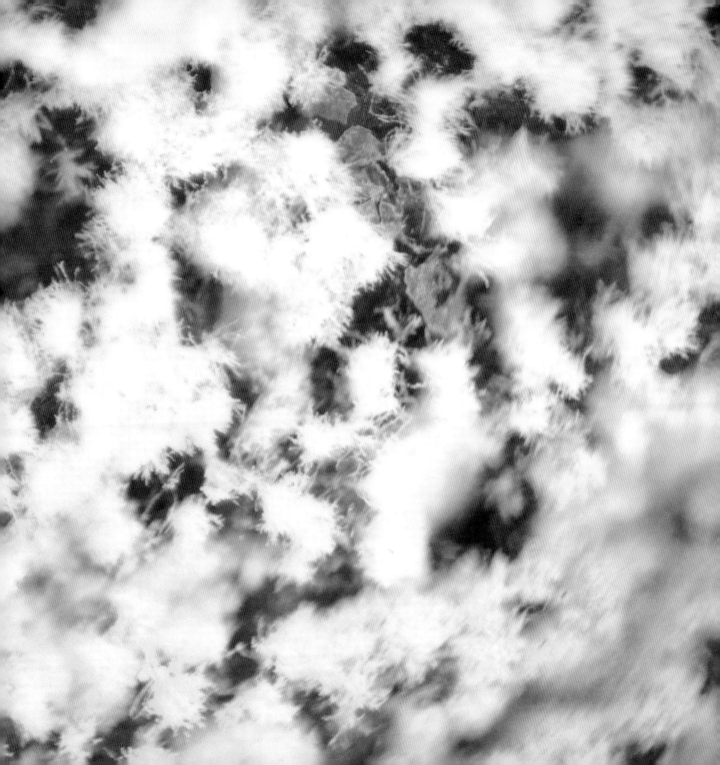

breath. People can be very bothered by certain smells! But does that make masking our everyday bodily odors a personal responsibility?

In recent years I have come to recognize that I am extremely sensitive to scents. I hate scented detergents and overpowering smells, such as heavily perfumed spaces in airports and department stores. I especially dislike products that are unexpectedly scented without labeling, such as trash bags. Smell is such an important and useful sense. Why are we so intent on manipulating the aromatic environment? Is the way we smell, the olfactory reminders of the physicality of our bodies, too much to bear? Is the evidence of our biological functions too animal for our delicate sensibilities?

. . . . . .

As with our body odors, we are in a state of collective denial about their sources: our sweat, our excrement, our intestinal gas, and the other inevitable by-products of our physical existence. We like to deny these coarse, inconvenient facts and maintain a collective fantasy that they do not exist. Yet, at the risk of being seen as crude, I must draw your attention to sounds and smells that many people desperately attempt to deny, hide, and mask.

Consider flatulence. For many people, farting in the company of others is one of the most humiliating things they can imagine. People avoid foods they associate with farting and think of farting as a pathological

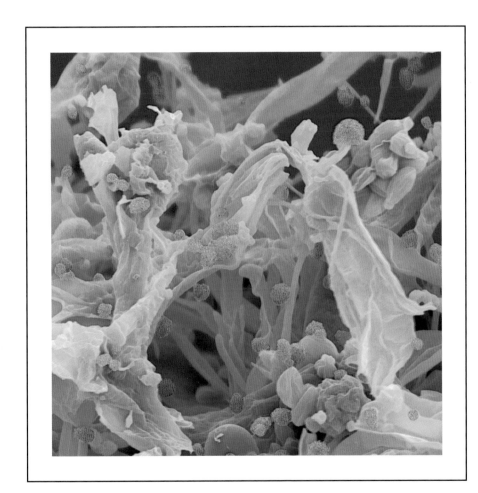

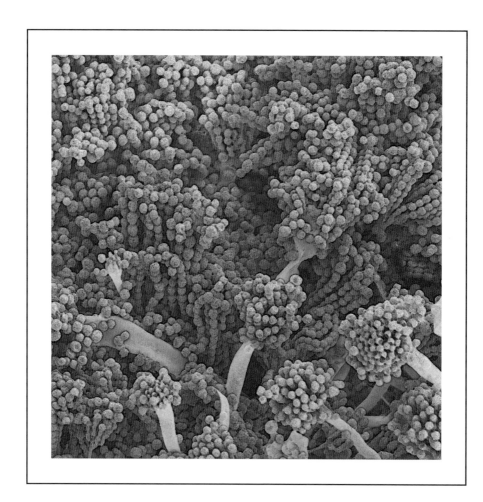

phenomenon, rather than the normal part of our digestion that it is. Farting is the release of carbon dioxide and other gases produced by the microbes of the intestines, especially the large intestine.

If we wish to support and restore microbiome biodiversity, which we must for continued well-being, then we need to feed the microbes of the large intestine, even though this will cause some farting. Most of the foods that are notorious for making us gassy are precisely the kinds of foods that are becoming known as prebiotics: oligosaccharides and fibers that nourish the bacteria of the large intestine thanks to our inability to fully digest them. Rather than avoiding these foods, we need to be eating more of them in order to support flourishing, biodiverse microbial communities in the colon. Ingesting high-fiber prebiotic foods is an important factor in effectively enhancing gut biodiversity, perhaps even more so than ingesting probiotic bacteria. Farting is not a symptom of disease or dysfunction; it is an inevitable by-product of a healthy intestinal microbiome being well fed, fermenting.

## the rebellious spirit

Like the literal phenomenon that inspires it, metaphorical fermentation is a force that cannot be stopped. In its food and beverage

manifestations, fermentation is unstoppable because bacteria and fungi are everywhere, and except under certain specific sustained conditions (such as extremely dry or cold), microbial transformation of our food is inevitable, for better or for worse. Those grapes could become wine, or they could become engulfed in a cloud of mold. That cabbage could become kraut, or it could decompose into slime. Clever people everywhere developed practical techniques to guide these inevitable transformations by manipulating environmental conditions so as to encourage the growth of certain organisms while simultaneously discouraging the growth of others.

In ancient cultural traditions all around the world, people have recognized fermentation by the bubbles it produces. The experience of most fermentation processes, from a sensory perspective, is felt, seen, and heard through the bubbles: anticipating them; their initial appearance; the gradual building of intensity; the constancy and sound of the bubbling at peak fermentation; then the inevitable slowing. That bubbling is the release of carbon dioxide, which builds in vigor with growing microbial activity and then recedes. The bubbles create movement, literally exciting the substrate being transformed by the fermentation, bringing it to life. Also, by showing us—the human beings creating the conditions for the ferment to occur—that our plan is manifesting, the bubbling excites and inspires us.

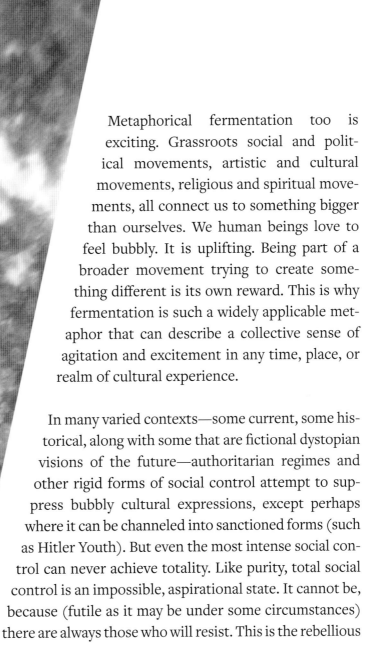

Metaphorical fermentation too is exciting. Grassroots social and political movements, artistic and cultural movements, religious and spiritual movements, all connect us to something bigger than ourselves. We human beings love to feel bubbly. It is uplifting. Being part of a broader movement trying to create something different is its own reward. This is why fermentation is such a widely applicable metaphor that can describe a collective sense of agitation and excitement in any time, place, or realm of cultural experience.

In many varied contexts—some current, some historical, along with some that are fictional dystopian visions of the future—authoritarian regimes and other rigid forms of social control attempt to suppress bubbly cultural expressions, except perhaps where it can be channeled into sanctioned forms (such as Hitler Youth). But even the most intense social control can never achieve totality. Like purity, total social control is an impossible, aspirational state. It cannot be, because (futile as it may be under some circumstances) there are always those who will resist. This is the rebellious

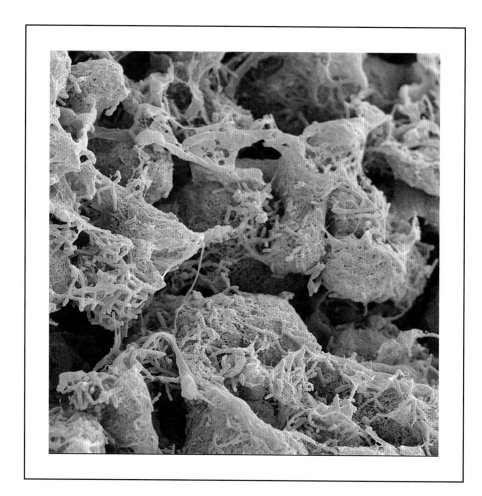

84

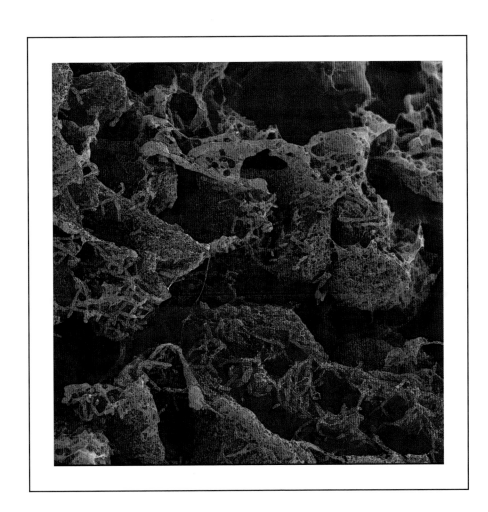

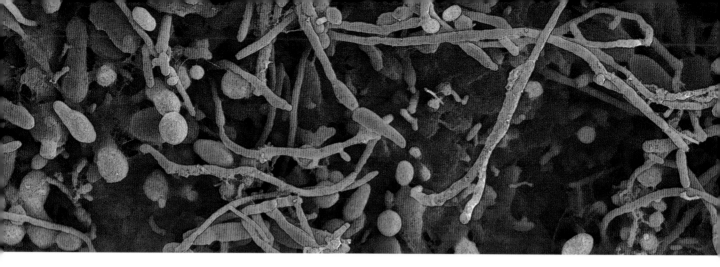

spirit. The rebellious spirit at its best is principled, allied with pur-
pose, but it can just as well be petty, peevish, or personal. The
rebellious spirit is an inevitable expression of refusal to go along.

It can be scary to stand up for yourself, or for others, or for ideals
you hold. The path of least resistance is to go with the flow. But
in any situation, there are people who refuse to do so. The rebel-
lious spirit manifests in different ways, but like fermentation, it is
a force that cannot be extinguished.

Just as we can cultivate so many other attributes, we can culti-
vate the rebellious spirit, encouraging critical analysis and action,
rather than discouraging it. Critical thinking is a form of fermen-
tation. The ideas or information or stories we are presented with
are the substrate. Our interrogation of them, whether silently in
reflection, or aloud as questions or challenges, is the bubbly agita-
tion. In this Age of Information, in which we are all oversaturated

with sensory stimulation, a critical approach is imperative to filter fact from fiction and draw our own conclusions.

Political transformation is fermentation. An authoritarian government or a multi-generational dynasty seeks to suppress it, while more dynamic models of governance rely upon it to respond to emerging social needs. A political theorist whose ideas always resonated for me is Thomas Paine. In his 1791 book *The Rights of Man*, he made the case that each generation possesses an inherent right to political transformation:

> *There never did, there never will, and there never can, exist a parliament, or any description of [people], or any generation of [people], in any country, possessed of the right or the power of binding and controlling posterity to the "end of time," or of commanding for ever how the world shall be governed, or who shall govern it: and therefore all such clauses, acts or declarations, by which the makers of them attempt to do what they have neither the right nor the power to do, nor the power to execute, are in themselves null and void. Every age and generation must be as free to act for itself, in all cases, as the age and generations which preceded it.*[9]

In my interpretation, this is not to deny the wisdom of ancestors, whose ideas always inform and influence present thinking. Nor is it

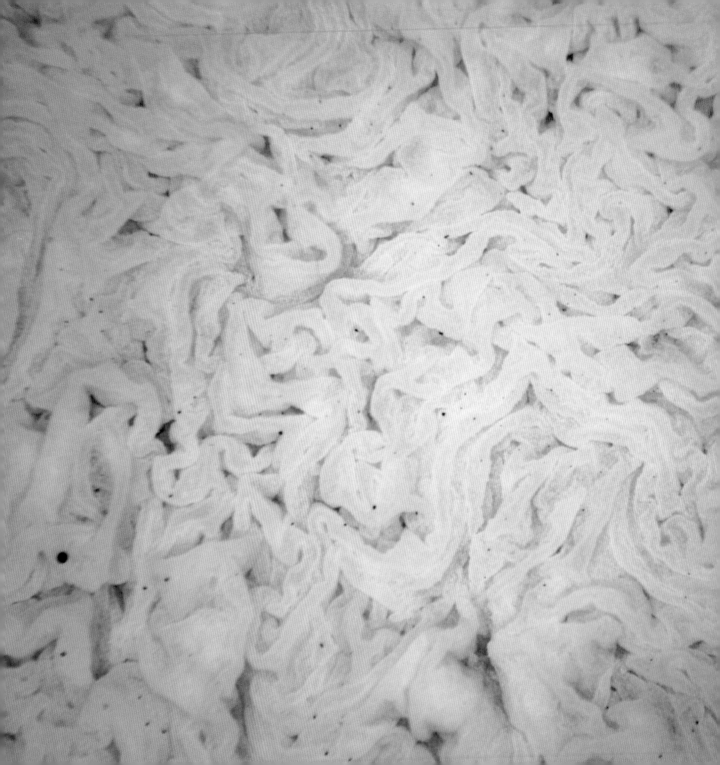

a justification for generational greediness. It's an acknowledgment of the constancy of change, and that all our thinking, governance, and structures must be resilient enough to accommodate new information, emerging realities, and ever-changing sensibilities. In the social and political realm, fermentation is an ongoing necessity and inevitability.

## emotional composting

As important as fermentation is in the social and political spheres, it is no less powerful in the innermost realm of our feelings. My friend Valencia Wombone, always fermenting ideas and sharing them, introduced me to the idea of "emotional composting." Valencia talks about multi-generational trauma, and its cumulative impact, especially as it relates to African American descendants of chattel slavery such as herself. The feelings that result from any form of trauma, most intensely trauma experienced generation after generation, cannot be overcome by ignoring or denying them. Overcoming the centuries-long multi-generational trauma of enslavement followed by so many further betrayals, cannot come about from denial. As a society, we must acknowledge the facts, and seek reconciliation through reparations. Descendants of slavery and indigenous tribes ought to be granted preferential treatment in every aspect of life, a

long-term commitment over multiple generations. Even with such societal support, and definitely in the absence of it, people have feelings, which must be acknowledged and felt in order to be transformed. Like food scraps and weeds in a compost pile, feelings can ferment into new ones that enable us to heal and grow.

When I asked Valencia how she started thinking about emotional composting, she credited the Taoist thinker Mantak Chia, who writes about the concept as follows:

> *Taoists reason that the negative emotions can be transformed to become our life force and positive energy. Therefore, to expel or suppress unwanted negative emotions is to expel or suppress life force. Rather than suppressing them, you gain more by composting and recycling—or experiencing these emotions and transferring the negative into positive energy. This means you permit them to emerge, observing and accepting them, but you do not let them run wild or trigger other negative emotions. Instead, you transform them not only into useful life force energy, but also into another, higher consciousness that is your spiritual energy.*[10]

I know little of Chia's broader ideas or the methods that he advocates, but as a metaphor for grappling with emotions, compost works. I've been an avid composter for decades, and I never cease

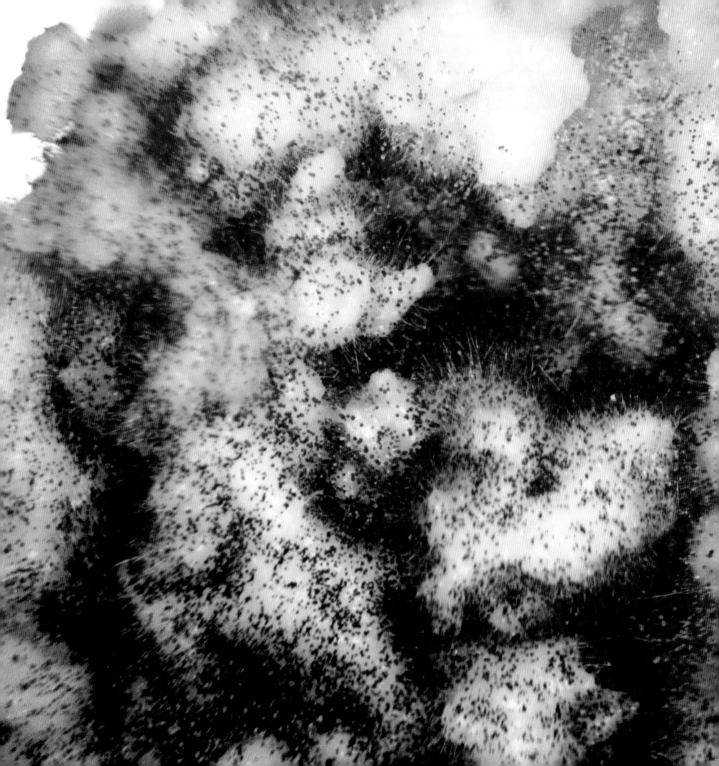

to marvel at the transformation. A pile of weeds, onion skins and vegetable ends, moldy old leftovers, decomposing fruit, manure, fallen leaves, and whatever other organic materials you might add, is consumed by the ravenous and all-encompassing appetites of worms, insects, protozoans, fungi, and bacteria and turned into humus, which regenerates the soil and nurtures further plant life. Compost is yet another manifestation of fermentation, and composting emotions is fermenting them.

The transformative fermentation of the compost pile offers a powerful vision for taking feelings that hold us back—feelings of shame or self-doubt, feelings that we are unworthy or unlovable, feelings of fear, anger, and resentment—and transforming them into new ones that better serve us and help propel our lives forward, not only as individuals but in our multiple overlapping collectivities.

## spectrum empowerment

The greatest promise of metaphorical fermentation is that it generates new forms. New forms of anything. I am particularly moved and inspired by cultural movements that are exploding binary thinking in favor of what I'll call spectrum empowerment. This is clearly happening in the realm of gender.

Today we are seeing growing social movements empowering people who do not fit neatly into the binary gender categories of male and female. The mainstream view continues to be dominated by the binary gender system, even though many ancient indigenous traditions carved out special roles for gender-nonconforming individuals. Contemporary transgender identities have been bolstered by online networking, as well as increasingly sophisticated hormone treatments and surgeries. Now growing numbers of people are identifying as gender nonbinary, or genderqueer, or genderfluid, among other permutations. As more people claim more nuanced identities for themselves, they create more space for others to further expand the spectrum.

Another emerging social movement claiming space on a broad spectrum is neurodiversity. This perspective rejects the dominant paradigm of a single model of mental health, which views any deviation from certain norms as mental illness. Instead, it views diverse neurological expressions as part of the normal range, and advocates for greater acceptance and accommodation to the fact of neurodiversity.

For many years I have heard from parents with children on the autism spectrum, who viewed autism as a disorder, possibly related to gut bacteria, and sought information on fermentation as a treatment to improve gut health and potentially improve their

children's conditions. I never really questioned the assumptions behind any of this until recently, when I received a letter from an adult on the autism spectrum who had enjoyed my books but had been taken aback by my discussion of autism in *The Art of Fermentation*, in which I describe the role of live fermented foods in some people's "recovery" from autism. This person wrote, "Autism is not a disease to be cured, but instead autistic people are just neurodivergent. Different, but not wrong." They continue: "As with most marginalized groups, many people within the dominant group wish the minorities to conform to their ways through assimilation, but what we should have instead is radical acceptance."[11]

I wholeheartedly concur. Many people "on the spectrum" are quirky and different in ways that allow these individuals to develop really unique skills. With nurturance and encouragement, many more neurodivergent people could have the opportunity to develop the things that make them special, potentially enabling them to contribute to society in huge ways, and to participate in life rather than being relegated to the margins.

When a group of people whose reality has been pathologized organize to claim respect for who they are, that is fermentation. Individual thoughts compel people into conversations that bubble and spread and bubble some more, building solidarity and mutual support, and perhaps resulting in some concrete demand. Decades

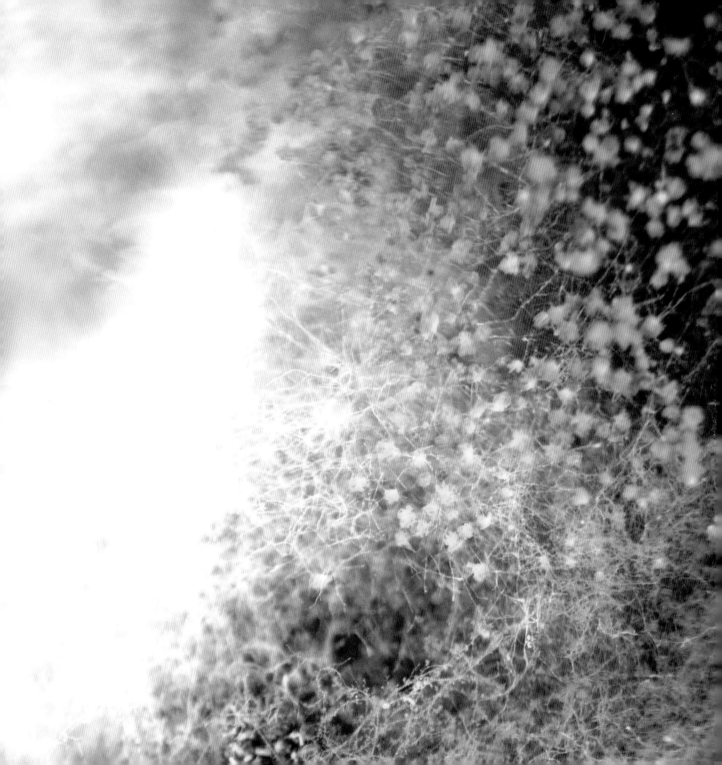

ago, in New York in the late 1980s and early 1990s, in the midst of the AIDS epidemic, I was part of the activist group ACT UP, the AIDS Coalition to Unleash Power. Because there were no effective treatments at the time and AIDS was viewed as a death sentence, press reports generally referred to people with the disease as victims, whether they had died or were still alive. It was demoralizing to people doing the best they could to stay alive, and in fact fighting for their lives, to be called victims. In ACT UP and other AIDS activist groups, people with AIDS claimed their agency and power by demanding that they stop being referred to as victims. A 1983 statement by the People with AIDS Coalition, known as the Denver Principles, declared: "We condemn attempts to label us as 'victims,' a term which implies defeat, and we are only occasionally 'patients,' a term which implies passivity, helplessness, and dependence upon the care of others. We are 'People with AIDS.'" For any group of people who share a feeling that they are being misunderstood or misrepresented, joining together to assert how they wish to identify is powerful and transformative fermentation.

## biodiversity

Metaphorical fermentation, the bubbliness and excitement of ideas, whether in a single person's mind or in collective expression,

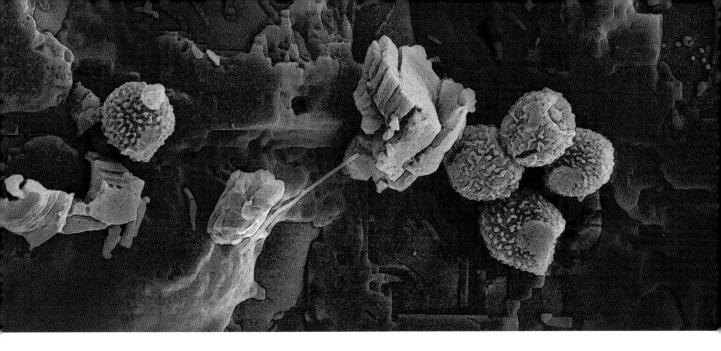

stems from the uniqueness of people: genetic difference layered upon family dynamics, culture, education, socioeconomic class, historical circumstances, and much more. Though all humans are related and share certain commonalities, we are also incredibly diverse, and ultimately each of us is unique. It is this diversity of perspectives that makes metaphorical fermentation inevitable.

Likewise, literal fermentation is a reflection of the fact of biodiversity. Literal fermentation is driven by the diverse bacteria and fungi, existing in elaborate communities in all environments, that find their way to grapes, wheat, cabbage, milk, and all the plants and animal products that make up our food. Biodiversity also drives the renewal of soil fertility, pollination, and ecological balances

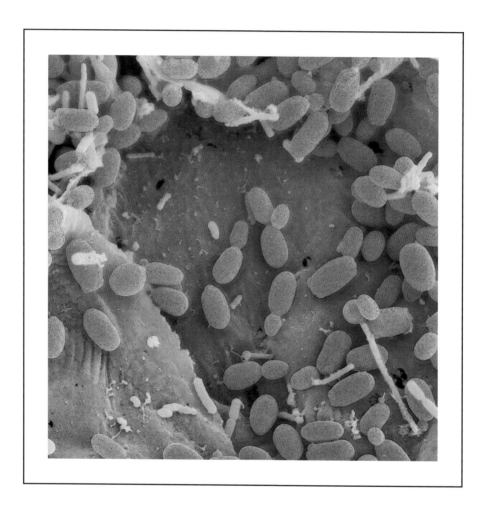

everywhere. Despite its critical role, Earth's biodiversity is diminishing rapidly, and many scientists warn that we are in the midst of a mass extinction event. These accelerating losses of animal, plant, and microbial species are attributed to a number of factors, all caused by human activities, including pollution, climate change, and loss of habitats to agriculture and development.

Many argue that clearing more forested land for agriculture is a necessary trade-off for sustaining a growing global population. But destroying habitats that sustain diverse plant, animal, insect, and microbial populations is a self-defeating trade-off. So is a style of agriculture that hastens soil erosion, depletes groundwater resources, and pollutes. Vast industrial monocultures relying on heavy chemical usage are not the only imaginable solution to feeding the Earth's growing human population. In fact, it's not a solution at all, since it intensifies so many other problems.

Sustainable regenerative solutions, such as polycultures using organic inputs, are much more labor-intensive and are therefore frequently dismissed as unrealistic. We've convinced ourselves that the only realistic model for producing food is monoculture: using big machines to grow endless rows of a single crop. Yet the fact of biodiversity will not permit monocultures to be sustained. Other plants (weeds) will grow, requiring weeding or herbicides. Insects will appear, requiring pesticides. Fungi will develop,

requiring fungicides. The contrived purity of monoculture requires a cascade of chemical interventions, none of which remains effective for very long, with evolution rapidly developing and spreading resistance to them.

Biodiversity makes our home on planet Earth a chaotic place. It is the dynamism of this diversity that gave rise to us and all the other forms of life we rely upon. We cannot think of all plants other than our specific cultivars as weeds. We cannot think of all insects, birds, and other mammals as pests. We cannot think of all bacteria, viruses, and other microorganisms as threats. We are not working with a blank slate, a petri dish, a pure substrate. We are creatures of Earth, among other creatures. Imposing our absolute boundaries and monoculture rows upon this matrix of biodiversity can never work. Life on Earth is too complex and intertwined for that.

The diversity of foods with which humans in disparate environments around the Earth have successfully

sustained themselves is a further reflection of biodiversity. Human beings have such vast powers of adaptability that we have been able to thrive from the tropics to the Arctic, in wildly different eco-systems offering radically different food possibilities. We do not require cornflakes and cheeseburgers to survive. We do not require the latest "superfood." Whatever is abundant in our environment, whatever we can most easily forage or grow, can become staple foods. Nutrition and health are about balance and context. No single crop or animal defines our destiny. We truly are omnivores, lucky creatures of versatility.

No particular fruit or grain or preparation holds a singular key to good health. Biodiversity is too great for that. Cultural diversity is too great for that, as well. Eating for health and nutrition cannot fol-low a singular path, without dismissing the accumulated wisdom of cultural traditions everywhere. Some dietary ideologues hold that human culture collectively made critical errors thousands of years ago, with original sins such as cooking with fire (raw foodists) or grain-centered agriculture (paleos). I absolutely support them all in eating how they wish to, but when anyone expresses certainty that their way of eating is the correct way we all should eat, I wonder: What makes them so sure they've finally got right what all the varied cultural traditions around the world evidently got wrong for thou-sands of years? Our food versatility and adaptability have been key elements of our species' success. The future belongs to the flexible.

# fermentation is not a fad, it is a fact

Obscured by the panic and fearmongering about the prospect of feeding humanity's rapidly growing numbers is the fact that fully one-third of all food produced for human consumption around the world goes to waste, according to the United Nations Food and Agriculture Organization.[12] Beyond what we produce as food, there are so many potential food sources that we are barely tapping into, such as acorns, insects, and seaweed. We must reorient our approach to food to eliminate waste, and to use what is abundantly available, as our ancestors everywhere did.

It's interesting to me that in the current fermentation revival, fermentation is frequently framed as a fad for affluent foodies, when throughout history fermentation has been an essential element of how people everywhere have made effective use of whatever food resources they have had available to them. Fermentation traditions are born of necessity and hold immense practical value for people who sustain themselves on the food they can produce or procure. Ironically, in sharp contrast with the notion that fermentation is primarily accessible and of interest to the affluent, in certain contexts, such as Sudan (as rural people migrated to cities[13]) and Siberia (as people had greater access to a more typical Russian diet[14]), the flavors and smells of fermentation have largely come

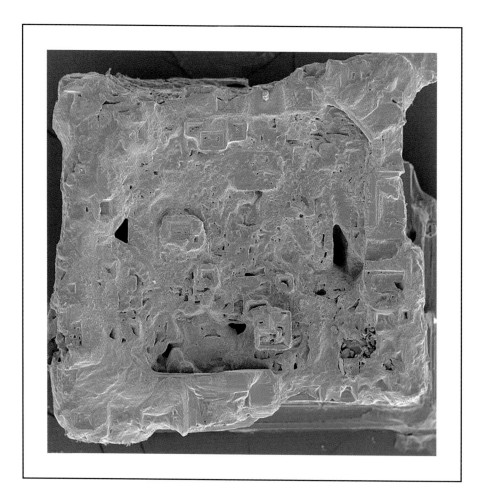

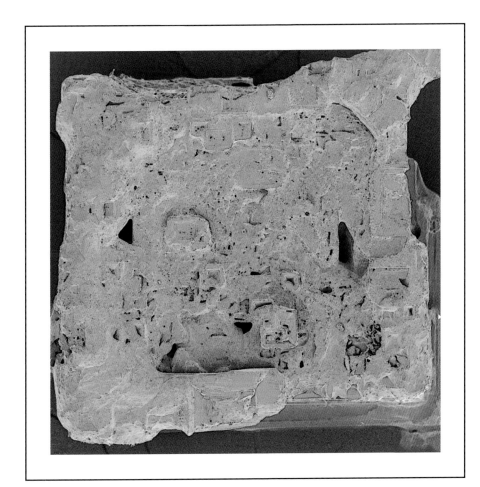

to be rejected, seen as an antiquated, cruder way of life, replaced by more modern foods.

Fermentation is not obsolete and it is not a fad. It is a fact. It is an inevitable life force that cultures have harnessed to create alcohol; to generate compelling flavors; to preserve food from times of abundance for times of scarcity; to make otherwise toxic plants safe to eat; to increase nutritional value and make food more easily digestible; to sustain health and heal illness; to restore and diversify our microbiota; to conserve and produce energy; and to regenerate soil fertility.

Fermentation also provides us with a powerful metaphor with infinite regenerative power. Especially at this perilous precipice, we need the creative force of fermentation. We are desperate for agitation and excitement in every realm of our lives. Our multiple existential challenges demand broad movements for social change. Simultaneously, and inextricably linked, are growing psychosocial challenges, demanding transformation in more ethereal interior realms, such as mental health, sexuality, and spirituality.

As I've been completing this manuscript, the world has been forced to confront the COVID-19 pandemic. In a matter of weeks, society as we have known it ground to a halt as distancing measures were implemented to slow the spread of the virus. The abruptness of the

change to our way of life created a cascade of social and economic problems: job losses, shortages of vital necessities, economic catastrophe, families separated by long distances or trapped in small spaces together, postponement of medical care, not to mention the huge scale of loss of life. Like any crisis, this abrupt change to our way of life also presents us with potential opportunities.

During this time, renewable energy overtook fossil fuels in the United States for the first time ever.[15] The dramatic reduction in traffic and industrial runoff caused immediate observable improvements in waterways and air quality. Can this potentially be a step in our devolution? Slowing down the frantic pace of life. More walks outside. Less air travel. Less centralized production, replaced by smaller-scale local and regional production. Less resource extraction. Less drive toward endless, accelerated economic growth. More regenerative agriculture and renewable energy.

I do not have answers or a program forward, only questions. But just as the mutation of viruses and bacteria is an inevitable creative force of nature, so too mutation is an inevitable creative force of human cultures. That's what metaphorical fermentation is, an infinite source of mutation, transformation, and regeneration. Fermentation is everywhere, invisible and unseen until bubbles begin to rise up. But once bubbles start to manifest, anything can happen.

# acknowledgments

For all the scanning electron microscope images in the book, I thank Middle Tennessee State University, specifically Joyce Miller of the MTSU Interdisciplinary Microanalysis and Imaging Center (MIMIC) and Tony Johnston, director of the Fermentation Science program there. I also thank Joshua Graver, who colorized the first of these images.

Beyond that, I thank my agent, Valerie Borchardt, and my publisher, Chelsea Green Publishing, for their encouragement with this project. At Chelsea Green I thank my previous editor, Makenna Goodman, who left before this project fully manifested but prodded me in the early stages. I thank Ben Watson, Pati Stone, Margo Baldwin, and the whole wonderful Chelsea Green team. I thank Shopping Spree and Spiky for early feedback on the manuscript.

I thank the incredible, passionate community of fermenters I have met all around the world in my travels. I continually learn from you, and you inspire me to continue to reflect on the nature of this compelling phenomenon.

I thank my beautiful family and friends.

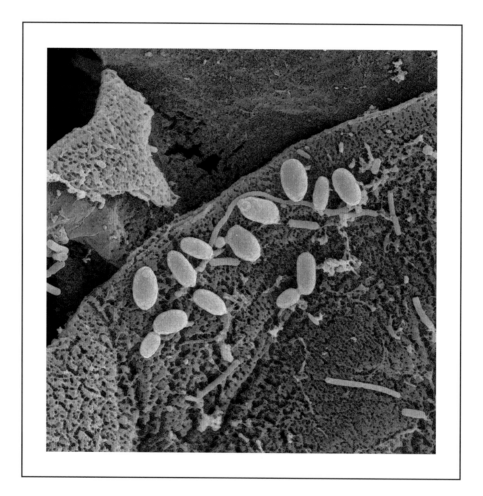

# photo descriptions and credits

Front cover: Tempeh fungus with scanning electron microscope. Copyright 2019 by Middle Tennessee State University Interdisciplinary Microanalysis and Imaging Center (MIMIC). Used by permission.

Dedication page: Crystal of dehydrated sauerkraut brine with scanning electron microscope. Copyright 2019 by MIMIC. Used by permission.

Page vi: Moldy cornbread with stereoscope.

Pages 2 & 3: Moldly millet with stereoscope.

Page 5: Miso with scanning electron microscope. Copyright 2019 by MIMIC. Used by permission.

Page 6: Doubanjang (Sichuan-style fermentation of broad beans with chilis) with scanning electron microscope. Copyright 2019 by MIMIC. Used by permission.

Page 8: Kahm yeast with macro lens.

Page 11: Sourdough starter with scanning electron microscope. Copyright 2019 by MIMIC. Used by permission.

Pages 12 & 13: Chestnut koji with macro lens.

Page 14: Tempeh with scanning electron microscope. Copyright 2019 by MIMIC. Used by permission.

Pages 82 & 83:  Kahm yeast with stereoscope.

Pages 84 & 85:  Kombucha mother with scanning electron microscope. Copyright 2019 by MIMIC. Used by permission.

Page 86:  *Tibicos* (water kefir) with scanning electron microscope. Copyright 2019 by MIMIC. Used by permission.

Page 88:  Kahm yeast with stereoscope.

Page 91:  Moldly millet with stereoscope.

Pages 94 & 95:  Moldly cornbread with stereoscope.

Page 97:  Crystal of dehydrated sauerkraut brine with scanning electron microscope. Copyright 2019 by MIMIC. Used by permission.

Page 98:  Radish kraut with scanning electron microscope. Copyright 2019 by MIMIC. Used by permission.

Pages 100 & 101:  Moldy bread with stereoscope.

Pages 104 & 105:  Crystal of dehydrated sauerkraut brine with scanning electron microscope. Copyright 2019 by MIMIC. Used by permission.

Page 107:  Moldy rice with stereoscope.

Page 110:  Sauerkraut with scanning electron microscope. Copyright 2019 by MIMIC. Used by permission.

# notes

1. James F. Meadow et al., "Humans Differ in Their Personal Microbial Cloud," *PeerJ* 3 (September 2015): e1258, https://doi.org/10.7717/peerj.1258.
2. César E. Giraldo Herrera, *Microbes and Other Shamanic Beings* (Cham, Switzerland: Palgrave MacMillan, 2018).
3. Mercedes Villalba, *Manifiesto Ferviente* [Fervent Manifesto] (Cali, Colombia: Calipso, 2019).
4. "Facts about Antibiotic Resistance," Infectious Diseases Society of America, accessed May 9, 2020, https://www.idsociety.org/public-health/antimicrobial-resistance/archive-antimicrobial-resistance/facts-about-antibiotic-resistance.
5. Massimiliano Cardinale et al., "Microbiome Analysis and Confocal Microscopy of Used Kitchen Sponges Reveal Massive Colonization by *Acinetobacter*, *Moraxella* and *Chryseobacterium* Species," *Scientific Reports* 7 (2017): article 5791, https://www.nature.com/articles/s41598-017-06055-9.
6. Heather Paxson, *The Life of Cheese* (Berkeley: University of California Press, 2012), 161.
7. Alan R. Templeton, "Human Races: A Genetic and Evolutionary Perspective," *American Anthropologist* 100, no. 3 (September 1998): 632–50, https://www.unl.edu/rhames/courses/current/readings/templeton.pdf.

8. *The Purity of Little Girls* (Randleman, NC: Pilgrim Tract Society).

9. Thomas Paine, *The Rights of Man* (London: J. S. Jordan, 1791).

10. Mantak Chia, *Cosmic Fusion: The Inner Alchemy of the Eight Forces* (Rochester, Vermont: Destiny Books, 2007), 59–60.

11. Personal correspondence, August 28, 2019.

12. "Global Initiative on Food Loss and Waste," Food and Agriculture Organization of the United Nations, accessed January 17, 2020, http://www.fao.org/3/a-i7657e.pdf.

13. Hamid A. Dirar, *The Indigenous Fermented Foods of the Sudan: A Study in African Food and Nutrition* (Oxon, U.K.: CAB International, 1993).

14. Sveta Yamin-Pasternak et al., "The Rotten Renaissance in the Bering Strait: Loving, Loathing, and Washing the Smell of Foods with a (Re)acquired Taste," *Current Anthropology* 55, no. 5 (October 2014): 619–46, http://doi.org/10.1086/678305.

15. Brad Plumer, "In a First, Renewable Energy Is Poised to Eclipse Coal in U.S.," *New York Times*, May 13, 2020, https://www.nytimes.com/2020/05/13/climate/coronavirus-coal-electricity-renewables.html.

## about the author

**Sandor Ellix Katz** is a fermentation revivalist. A self-taught experimentalist who lives in rural Tennessee, he is the author of two best-selling books on fermentation: *Wild Fermentation* and *The Art of Fermentation*, which won a James Beard Foundation award in 2013. He has taught hundreds of fermentation work-

Joel Silverman

shops around the world, which have helped catalyze a broad revival of the fermentation arts. The *New York Times* calls Sandor "one of the unlikely rock stars of the American food scene."

Sandor has broad ranging interests and always seeks to expand the context for thinking about fermentation and food. Following an extensive 2003–04 tour across the United States for his first book, *Wild Fermentation*, he was inspired to write *The Revolution Will Not Be Microwaved*, documenting grassroots food activists he encountered through talking with people about fermentation. This book is his latest attempt to encourage people to think about fermentation in expansive ways. For more information, check out Sandor's website: www.wildfermentation.com.